The Inner Circle Chronicles

Intuitive Healers Leading the New Economy
with Integrative Health, Soul, and Spirit

Book 3

Dear Allison,

from my oracle card deck:

" Inner Peace is ~~Heaven~~ "

You have a beautiful connection with nature, angels, and fairies. Love + Blessings

Ann

Other books from Inner Visions Publishing:

Inner Circle Chronicles—Book 1
12 Intuitive Women Leaders of the New Economy,
Transforming Lives and Businesses with Soul and Spirit

Inner Circle Chronicles—Book 2
Intuitive Women Leaders of the New Economy,
Transforming Lives and Businesses with
Divine Heart and Soul Around the World

Books by Anne Deidre:

Extreme Intuitive Makeover—
55 Keys to Health, Wealth, and Happiness

Miraculous—
How Spiritual Awakening Cured My Depression,
Inspired My Purpose, and Ignited the Intuitive Powers Within

Forthcoming 2016
Intuition: 6 Basic Instincts to Change your Life

The Inner Circle Chronicles

Intuitive Healers Leading the New Economy
with Integrative Health, Soul, and Spirit

BOOK 3

Inspired and Edited by
Anne Deidre

Inner Visions Publishing
New Hampshire

Copyright © 2016 by Inner Visions Publishing
All rights reserved.

DISCLAIMER: The information provided in this book does not constitute legal, psychological, medical, or financial advice. Readers are responsible for their own choices and actions.

Published by Inner Visions Publishing
www.InnerVisionsPublishing.com
in collaboration with HenschelHAUS Publishing, Inc.

ISBN:978-1-59598-460-9
E-ISBN:978-1-59598-461-6
Library of Congress Control Number: 2016934218

Printed in the United States of America

*This book is dedicated to the Divine Spirit,
the source of all universal light energy and healing,
and all change agents who are bringing forth
this Divine Energy to raise the vibration
of the planet and transform the world.*

Table of Contents

Introduction—Anne Deidre, Editor 2
Intuitive Healing—Anne Deidre.. 7
What's Missing From My Life?—Annette Calendine 10
Silence Allow Follow—Vida Groman............................... 22
The Faith in the Eyes of My Children—Julie Hartin......... 34
Recollections of a Starseed—Jolie Hasson 46
Learning to Thrive—Donna Kirk 52
Just Like the Tin Man—Jane Sapienza Lorenz................. 64
My Unexpected Path to Wellness—Lori Otto 74
The Gifts of Spirit—Denise Silvernail.............................. 82
Take Flight—Deborah Lea Smith 92
My Journey into the Akasha—
 Communicating with Spirit—Nancy Smith 102
Overcoming Fear—Eva Thompson 116
Thirteen Squadron Angel—Christy Yacono 130

Afterword—Anne Deidre .. 141
About Inner Visions Publishing 143

The Inner Circle Chronicles

Intuitive Healers Leading the New Economy
with Integrative Health, Soul, and Spirit

BOOK 3

Anne Deidre

Anne Deidre is an International Celebrity Expert on Intuition, Certified Medical Intuitive, Best Selling Author and Publisher, Professional Artist, Speaker and Coach. She has been featured on ABC and NBC TV, on The CW TV Network, HuffPost Live, also a FOX News Radio Contributor, on NPR, CBS Radio, Business Talk Radio, and many print publications such as Examiner.com, Beliefnet and *Aspire* magazine.

Anne's work is channeled from the Divine Energy and Frequency that includes Spirit, Ascended Masters, Archangels, and each soul's Divine Self to shift energetic patterns, catalyze dormant gifts and talents, and ignite the Divine intuitive powers within each person.

Anne's transformational gifts allow her to intuitively shine a light into her clients energy system and illuminate their hidden and/or dormant Divine gifts and talents that their soul is here to share. Her unique and powerful gifts allow her to shift energetic patterns, heal trauma, and create new patterns so that they can bring their Divine gifts to the world.

Anne has created Visionary Intuitive Academy with platinum private and group coaching for future thought leaders, spiritual teachers, and professional intuitives. Please visit her website for more information.

Contact Information:
Email: team@annedeidre.com
Website: www.annedeidre.com

Introduction

My art does imitate my life. It is with great joy and honor that I introduce you to what I call some of the Rising Stars of Integrative Health and Energy Medicine. Being the Third book in this series, I have found that what I am doing in my life is reflected in each particular book. There are no accidents. Already working in healthcare as a Licensed Nurses Aide and Hospice Worker, I also trained as an Advanced Medical Intuitive this year.

This book and Series is Divinely Guided and Orchestrated and I am honored to be the Divine Channel welcoming it into the world. Many men and women on this planet have been medicine men and women, whether you believe in past lives or not, there is a wholeness, healing and natural ability to work with God and health as is taught in many religions. This series contains a universal spirituality that has been embraced around the globe.

You will meet fascinating women in this book, which is true to the theme of the entire *The Inner Circle Chronicles* series. They have gone through something difficult, awakened to their True Nature and then became powerful channels of Divine Energy and Integrative Health and Wellness. Many around the world are Awakening to Energy Medicine, the Energy of Divine Love that I feel Jesus the Great Master Healer harnessed and transmitted.

I have been Divinely Guided as an Intuitive Healer and have been working for over twenty years with Divine Energy to

catalyze and awaken dormant gifts and talents, clear blocked and dense energy in the chakras and one person at a time, shift the energy on this planet into a higher vibration through my artwork, books, sessions, coaching, classes and audios. I could not be in better company and have loved coaching and working with these powerful women, who are changing the world as Intuitive Healers Leading the New Economy with Integrative Health, Soul and Spirit.

May you find all that you are looking for within, and with the help of these stories that each woman generously shares, may you feel comfort in knowing all health and wellness that you seek is within you.

<div style="text-align: center;">
God Bless You and Namaste

Anne Deidre
</div>

The Inner Circle Chronicles

Intuitive Healers Leading the New Economy
with Integrative Health, Soul, and Spirit

Book 3

INTUITION

6 basic instincts to change your life

Anne Deidre

Forthcoming in 2016

Intuitive Healing

By Anne Deidre

A preview of Anne's new book:
Intuition 6 Basic Instincts to Change Your Life
Forthcoming Spring 2016

Intuitive Feeling ~ Trust Your Gut and Your Heart

***What I Feel For Sure ~
Feel and Harness Your Emotions***

Many of you reading these words have been very sensitive your entire life. You may have been teased or been told that being sensitive was somehow wrong. In my life and great work, by paying attention to the Calling Within, I have been guided to share with you that when Sensitive is seen by you with a capitol "S," you will begin to see yourself differently and experience gratitude when you recognize how very powerful your Sensitivity is.

The first basic instinct for Intuition is Clairsentience, or "Clear Feeling." We have not been taught to feel our feelings, notice them or harness them. Many of us have been taught to ignore our feelings, to stuff them down, to distract ourselves, to do anything but feel them.

As an Intuitive Life Coach, I was guided by my intuition to witness the uncomfortable feelings of my clients in order to free them from these energies of fear, anger, and sadness and to help my clients feel more joy and love. Then they could connect with their own intuition more easily.

Intuition is not just a matter of trusting our gut; we have to be able to feel our feelings and release them and we have not all been taught how to do that effectively. There is an art and science to this. I will teach this art and science in this book.

Over twenty years ago, I found myself feeling the worst possible feelings in response to everything "going wrong" in every area of my life. Having been a Sensitive person my entire life, the one in the family that felt everything, I had learned to shut off my feelings with food, alcohol, and cigarettes. Born in the 1960s, I was not alone in experiencing life by not talking about it. Talking about feelings that were uncomfortable only seemed to make others uncomfortable. I joke with my clients that I had become like a "mute" at some point in my teens, because it seemed to hurt peoples feelings when I spoke my truth, which included how I felt.

Society and conditioning support the repression of feelings, and my own ignorance kept those feelings "in the dark," unexpressed, and unknowingly at the time, wreaking havoc with my energy, body and life. Now as an Intuitive Life Coach, I see, feel, hear, and know information for my clients. Whether they are aware of that information or not, their unexpressed feelings are wreaking havoc in their energy, body and life too.

I am a natural-born Intuitive Healer, but for most of my life, the journey was to heal myself, or better described, to realign my energy to a higher vibration, to learn a blueprint for learning not to shut down and shut off as I began to work on my own energy. I

began to see the inherently Divine Perfection that is there, so not as to heal but to Realize the Wholeness that is already within.

We will look at some feelings now from a vibrational perspective. All emotions and feelings have energy. Scientific studies have been done in this area of vibrations, energy and frequency. Dr. Emoto in *The Hidden Messages of Water* shows through the photography of frozen crystals of water that what we say out loud translates into messages and impacts everything around us. Thoughts, feelings and emotions do the same thing.

Let's look first at the energies of sadness, fear, and grief and understand that the weight of these feelings is heavier, or dense. When you feel sad, you might say you feel "down" because the feeling of sadness is a dense energy that actually is weighing you down. Let's look at emotions and feelings more closely and work with them to connect with your intuition more deeply.

(Excerpt from Anne Deidre's forthcoming book, Intuition.)

Annette Calendine

Annette Calendine is a wife, mother and passionate advocate of health and wellness. She is a medical ultrasonographer working at her local hospital. She has had years of seeing firsthand what poor nutrition and anxiety can do to a person's health and happiness. Annette has studied for over twenty years in the field of nutrition, herbs and alternative health therapies. She has investigated hormones and their importance for the past 10 years.

Both of her children are now in college studying in the medical field. With her husband's encouragement, she has teamed up with her sister, Laura, and together they present seminars and educate on health and wellness. Their company, Simplify for the Health of It, will be helping people find their happy place. They will use their combined knowledge of nutrition, essential oils, herbs and hormone balancing. Life coaching methods along with tapping (Emotional Freedom Technique), Reiki and meditation practices will be merged into the final product. Their programs will be based on intuitive abilities which will bring forth soulful platforms. Their first book, *Prevent Disease with Ease,* will be available at the end of 2016.

Annette lives in Ohio with her best friend and husband, Rick. They have two college-aged children, Tommy and Cassie.

Contact Information:
Email: acalendine@yahoo.com

What's Missing From My Life?

By Annette Calendine

"But, Mom, you're relatable." This is what my daughter, Cassie, stated when I was voicing my concerns about writing this chapter for Anne's book. I wasn't sure why I was here with Anne telling my story as there were no great highs and lows. The plots were not filled with suspense and drama. There were no traumatic moments that changed my life. I haven't always been in tune with my health and spirituality. I didn't have the sixth sense, well, that I listened to, anyway. I am just "normal"—as much as normal can be. I have a wonderful husband along with two great children. I have a respectable career as a medical ultrasonographer, where I try to help patients with both careful imaging of their anatomy along with trying to ease their worries and concerns over health issues.

Why would anyone want to listen to my story? Maybe because there are others out there who are blessed to have a wonderful life, but still have the sense that something is missing. That something has been a journey for me. My husband could not understand what I was looking for, and to be truthful, I didn't understand it myself. I just knew that there was something out there, so I absorbed everything like a sponge and it became my obsession.

I grew up in a small town in northern Minnesota. We were the traditional Catholic family with my mom and dad, my two

sisters, Cheryl and Laura, and my younger brother, RJ. Our town was built by the mining company in the 1950s so that people could move there and work in the taconite iron mines. The town was filled with young families and lots of kids. We never had to look far to find somebody to play with. It was a fun place to grow up, although there were many lean years due to strikes and layoffs at the mines.

I had a childhood where we ate everything "organic," although there really wasn't that buzzword around in the early 1970s. My mom and dad grew a garden and my mom baked everything from scratch. We always had homemade baked goods and paper bag lunches. There were times when I would trade my mom's baked rhubarb bars for a Twinkie. I thought those kids were so lucky to have their white bread and processed goodies, while I had baked bread and fruit and vegetables. We had chickens and beef from my grandparent's farm, so we ate healthy even though I just wanted TV dinners like a lot of my friends had in their homes.

My spiritual education came from attending our Catholic church. My earliest memory of our priest was of him pounding his fist and telling us that we were going to hell. He scared me. But, my mom and my grandpa and grandma showed me another side to God. He was good and loving and that He wanted the best for us. My mom talked about angels and when we had hard times, my mom just prayed. She knew that it would all work out. She always had a strong faith and still does. I remember my grandpa telling us that all you ever needed in life was to believe in God and to have a good lover. Good advice!

My best friend, since 7th grade, was Lori. We were "weird" and we went out of our way to be different from everybody else. Lori and I loved the spiritual realm. We liked using the Ouija board and Lori liked to talk to the people who had passed. We

What Is Missing From My Life?

were just dipping our toes into the spiritual world and we were somewhat afraid to do anything too out there due to our Catholic upbringing.

I attended business school in Minneapolis and was poorer than dirt. I lived off rice and pancake mix. The only time I ate anything different was when my boyfriend, Rick, took me out to eat. I didn't cook and we ate at fast-food restaurants. After I had a job, I had more money and I invented the "pop" diet. This included pop, popcorn, and popsicles. These were all part of the major food groups, right? It was so amazing that my body could even sustain itself with all of the junk I put into it. To my credit, I did exercise every day, so at least I had that.

I started on my holistic health journey in 1991, when I was introduced to a couple who lived in a farmhouse in southeastern Ohio. I was told that this couple could "read your eyes" and tell you what your body needed. It was called iridology and it fascinated me. Along with my reading, they told me what herbs I needed to get to a healthier place within my body. I started studying herbs and also iridology.

Certainly, there are people who dismiss this form of health reading and healing, but it really resonated with me. I applied this type of healing to family and friends and it was considered a type of entertainment, more than anything "real." I now had an inkling of a passion that was not going to go away quietly. In addition, there was some apprehension. I am in the medical field; we deal with facts and science; not positive energy and feel good foods. But, I was hooked and I set about on a journey that brought me where I am today.

I worked with a good friend, Janet, who was also into herbs and health. We were pregnant at the same time and both felt very blessed that we were going to be mothers. When I was pregnant with my son, Tommy, I was so amazed that God gave me the re-

sponsibility for this new life. I would not even consider putting anything in my body that could hurt my baby. I started studying nutrition at this point, along with my continued studies of herbs. If you had an ailment, I knew that there were herbs that could help. I had several books and would study whenever I had a chance. The Internet would have been so helpful! As it was, I had several books and magazines from which I got my information.

Many people live their lives thinking that if their parents or family members suffered from some type of illness or cancer that they are bound to suffer from that particular ailment also. I disagree. Granted, there are disease processes that have hereditary factors, but most of today's chronic diseases are familial, meaning that we tend to have lifestyles the same as our parents and their parents. My dad had cancer three times, suffered from heart-related issues, high blood pressure, gout, and arthritis. I do not own his history. My dad did not live his life with a healthy lifestyle. He ate too much, drank too much, did not exercise, smoked for most of his life, and did not do well controlling his stress. He worked shift work so his sleep patterns were all over the place. I now know why he was so crabby when we were growing up.

When my children were little, I started them from birth eating healthy. They had the cookies and junk food from Grandpa and Grandma, but I had limits on what I wanted them to eat. One of the first "devil" foods in my mind was hydrogenated oils. These are found in a variety of processed foods. According to the Mayo Clinic, the FDA has made a preliminary determination that partially hydrogenated oil is no longer "generally recognized as safe" and should eventually be phased out of the production of food. This may take several years due to the lengthy review the process must go through to become finalized. *The Natural News* stated that partially hydrogenated oils are only one molecule away from

What Is Missing From My Life?

being plastic. Imagine munching on a plastic bag for lunch...not too far of a reach! I read every food label and was amazed at the amount of foods that contained this harmful ingredient.

We took yearly trips to Minnesota where my family continues to live. My sister, Laura, told me a few years ago that she would give my kids junk food that contained theses oils and tell my kids not to tell me. Nice going, Sis! Of course, my kids were in heaven with all of these foods they were not allowed to have at home. To my sister's credit, she had a health scare and changed her ways. She is now a promoter of health and wellness. She is my perfect partner to help guide clients through the education of nutrition and other holistic processes.

When my daughter was in first grade, her teacher brought cookies in for her class. My daughter read the label and promptly told her teacher she couldn't eat the cookies because they had hydrogenated oils. The teacher couldn't even pronounce the word and didn't even know what Cassie was talking about. It still makes me laugh thinking of my daughter, who was only six with blonde pigtails, telling her teacher about hydrogenated oils.

In 1999, my husband, Rick was in an automobile accident. He suffered severe whiplash. He was prescribed several anti-inflammatory meds along with pain meds. He is an electrician, which is a very physical job, and he was unable to work a full week for over a year. Although my husband always supported me and my holistic ways, he wasn't convinced that this was the way of life for him. He loved his sweets and fast foods. But the meds were tearing up his stomach and he was feeling miserable. He had to stop taking karate classes and riding his motorcycle due to the pain he suffered from constantly. He decided to come over to the holistic side and was willing to try the herbs. This protocol made a huge difference. He credits it for saving his life.

In 2006, the hospital, where I work, held a health fair. That is where I met Lorna, a Reiki Master. She was giving out cards to have a Reiki session. I was kind of leery but my friend, Jackie, told me that she was going to go, so I decided to do it also. The first thing that I told Lorna was that I was a Christian and that I didn't want anything to do with Satan or anything that would offend God. Lorna told me that God had given her this ability. I was hooked.

Lorna stated that she could give lessons, so I decided to go along with a few friends. This was the start of my spiritual connection to health. I took the first two levels and then went on to get my Reiki Master level of Natural Healing.

Reiki is a form of energy healing where the practitioner uses his or her hands to feel the energy that all people radiate. We guide the energy and move the blocks, which allows blood flow and healing to occur. I have had some friends with concerns regarding this type of healing due to its non-denominational methods. I feel a strong connection to God while I perform these sessions. I am the vessel that God uses to help the people that I am performing Reiki on. After my husband's success with the herbs from his car accident, he allows me to perform Reiki on him on a weekly, sometimes daily, basis.

So I had a fair share of my alternative health methods, along with a strong foundation of nutrition. But, I was in my early 40s and I started to feel like someone else. I was easily irritated, I developed hormonal migraines, and I would get mad at the drop of a hat. I ate well, exercised, and did everything I was supposed to be doing. Why was I feeling so bad?

I went to my doctor and was told I could be started on antidepressants. But I wasn't depressed! Granted, I could cry at any moment and was easily distracted and foggy brained. I therefore started another journey. I started researching hormones and the

What Is Missing From My Life?

effects of imbalances and their complications in your life if they were not in harmony. I came to the conclusion that I was a perfect candidate for hormonal imbalance. I worked full time, had two active children in sports, was on call at the hospital, and had a million other things that needed to be done on a daily basis. I was also in perimenopause. This is a time when your ovaries slow down with their production of estrogen, progesterone, and testosterone.

In today's world, most women are estrogen-dominant. This comes from our environment, such as using plastics. If you heat up food in plastics, drink water from a plastic bottle, and so on, realize that all of these plastics contain BPA. This is basically a fake estrogen. PABA in all of our lotions, soaps, and makeup are another way that our body is absorbing these fake estrogens or xenoestrogens.

This isn't even the tip of the iceberg. We are eating meat that is shot full of hormones to make the animals larger and stronger. We are eating eggs and drinking milk that have hormones. Most of these hormones are estrogen-related. We have become a society of estrogen dominance. The girls are now much younger when they start puberty. There is an increase in the rise of PMS, bleeding irregularities, infertility, fibroids, and other ailments. The list is very long.

Our bodies are like finely tuned machines. Estrogen and progesterone need to be hand in hand. Progesterone is the calming hormone; it regulates our moods and menstrual cycles. When this is out of balance, a nice, calm lady can turn into a monster on a dime. That is what was happening to me. Not fun for me and even less fun for my husband and children.

I went on to research bioidentical hormones. There is such a misconception of these prescriptions. First off, they are only prescribed by physicians. They are formulated by pharmacists that

have additional training in bioidenticals. The pharmacies are regulated by the FDA. The pharmacist will speak with you to find out what your symptoms are, which can take up to an hour consultation. The pharmacy will then mix the combination for you and only you. Unlike synthetic hormones, this prescription is applied topically on the skin, therefore eliminating the risk of blood clots. The research has been ongoing for over 30 years for the bioidenticals. To date, there is no known direct link to blood clots, cancer, or even heart disease.

I was very fortunate to be blessed with a wonderful doctor. She wrote an order for my hormone levels to be tested and with the results in hand, also wrote a prescription for my progesterone cream. Even though I ate organic foods and did all of the right things, I had taken birth control pills for five years. I ate horribly in my twenties, so it was all coming back to haunt me.

After the first month of being on the prescription, I felt like myself. No more mood swings and migraine headaches. I have had to increase my dosage after a few years and I also take a testosterone supplement. Even though we can be estrogen-dominant, we can still be low on estrogen. Again, with phytoestrogens, foods can supplement our lowering levels due to age.

I continued on with my studies of nutrition and herbs and yet, I still felt like I was missing something. There was something else I was supposed to be doing. In 2011, my sister, Laura told me she was going to take classes to become a Life Coach. I was jealous, as this was something I was really interested in.

Jennie Antolak, co-owner of Learning Journeys, was willing to Skype my lessons, so after a year of classes, I became a Life Coach Practitioner. This opened another path of my education into health. I realized that the mind, body, and soul connection is what contributes to health, not just the physical body aspects.

What Is Missing From My Life?

I was thirsty for so much more. The more I learned, the more I felt the need to learn. I ended up reading more books, listening to more online seminars, taking more courses and learning everything I could get my hands on. There are so many different options on health with the mind, body and of course, spiritual!

I took a course from an accredited hypnosis school and received my hypnosis degree. I learned about Tapping, a method which combines both psychology and using pressure points. This is a wonderful way that has helped people deal with anxieties and their self-sabotaging ways.

Essential oils have also become a part of my life. There are times when our diets are hard to control along with our environment. That is where essential oils can be used to help us live a better life by helping our bodies supplement what they are missing.

In 2014, I heard Anne Deidre on a tele-summit. I had never listened to this particular program and I'm not even sure how I came upon it. I listened to Anne and instantly felt a connection with her. She was offering a reading and a clearing of my energy. I just felt a need to learn more, but I had no idea what I was going to do with all of this knowledge. I felt scattered. After speaking with Anne, she told me that she thought that I would be a good fit for her third book in her series.

I had my doubts. What story could I tell? Anne asked me what I was passionate about and I told her about my love of nutrition and helping people live healthier lives, both physically and mentally. I have an internal push to speak with people about nutrition, hormone balance, and holistic ways to help themselves. There are so many people who struggle with health issues, both mental and physical.

There is a finely tuned connection with your internal spirit and your health. I am compelled to follow the lead of this drive

that exists within me. I believe that people aren't aware of how to better their lives. They accept that pain or suffering or poor health is how life is and they accept it without any fight. Life isn't meant to be so hard. I am always searching for ways to connect, relate and work towards helping others heal on a level much higher and more purposeful to their lives.

I also believe that God has given us our intuition to help our lives. I did not feel I had this ability and I was always amazed at the people who just "knew" the right answers. So, I started investigating the science of intuition. I thought that it was a skill that you had to be born with, but I soon discovered that we all have this ability. It is like a muscle...we just have to work it. I studied Sonia Choquette's course as an Intuitive Practitioner. Quieting the mind and using our intuitive skills are key parts of helping people figure out what is the root cause of their problem.

After many years of education and being a student of holistic ways, I have finally found my way to have a voice. I have teamed up with my sister, Laura, and we have formed a company called *Simplify for the Health of It*. We are now promoting easy and fun ways people can change their lives for the better. We combine mind, body, and spirit in our seminars so clients can get a full range of services. By only concentrating on nutrition, for example, you can eat right and still be miserable if you don't deal with your internal issues. There are times that people don't really know what is wrong with their lives; it may be buried under several layers.

It has been a fun journey getting to this point. I have met many wonderful people who have shared their skill sets with me. I'm hoping that we can repay them by spreading our knowledge to anybody who is not living their most joyful and healthful life. It is our mission to help uncover and replenish the whole being.

What Is Missing From My Life?

*What I am doing today is important
because I am investing a day of my life in it.*
—Unknown

SIMPLE SELF-CARE STRATEGIES

- Eat REAL food: Lean proteins, healthy fats, non-refined carbs (fruits & vegetables). Basically, no processed food.
- Eat mindfully: Slow down and enjoy the food you just prepared.
- Take time to plan your meals.
- Manage your portion sizes.
- Drink water. Take your weight, divide by 2 and that is as many ounces as you should be drinking.
- Use spices as they are a powerful antioxidants, which fight inflammation. (Turmeric is my favorite.)
- Consider taking supplements as we don't get the nutrients our body needs from food alone. Take probiotics and Vitamin D3 at a minimum.
- Manage your thoughts….they are very powerful!!
- Move your body. We were never designed to sit all day.
- Sleep 7 to 9 hours a night. Go to bed and get up at the same time every day!
- Manage your stress by simply breathing. Meditation has been a proven method of reducing and managing stress.

Vida Groman

Vida Groman is a healer and spiritual counselor who has an intuitive ability to see, sense and activate the Divine Light and Power within her clients.

Vida considers her life as the Great Teacher above all and it is through her life experiences that she has deepened her connection to her Soul and Spirit, empowering others to thrive with this mystical connection as well. This is one of the many reasons people love working with her. With her unique combination of natural gifts, healing abilities and trainings, a session with Vida will help open the inner doorways of your soul to help you see what may have been hidden to allow more and more potential for growth and abundance in every area of your life. Vida offers personal sessions, coaching and workshops in Divine Service to help her clients expand into all that they are here to experience.

Vida Groman has an MS in Counseling, is a Certified Soul Directed Healer as well as a Perceptual Thinking Patterns Consultant. She is also an Access Consciousness Bars Facilitator and Practitioner, Certified Professional Coach, Certified Heart Math Teacher, Certified Angel Reader, and Author.

Please visit her website and receive your free gift, "10 Tips for Living Alive: Simple, Elegant, Effective Ways to Find Yourself", a special guide filled with her intuitive photographs that align you with the energies of joy and peace.

Contact Information:
You can learn more about Vida's services at www.vidagroman.com

Silence Allow Follow
LIVING LIFE FROM THE INSIDE OUT

By Vida Groman

Oh, to be slow enough to listen and hear the wisdom of my ages. That, I ask for over and over again. And then my life will unfold from the depths of me, shining forth into the light of day. Yes, to slow down, listen and to shine forth.
This and more do I want.

What value will my history, my pain, and my joys have for those who read this? I believe that knowing there have been people who have experienced difficulties and sorrow and have survived with a better sense of self can serve as inspiration for others as they take the next steps of their lives.

Let's begin:

I invite you to join me in a dream that I had many years ago now. Imagine a circle of ancestors sitting on rocks and logs of wood around a beautiful fire. Imagine that I am standing at the head of the circle with a beautiful Spirit Being standing beside me. There is such quiet all around me. A very small, elderly woman walks up to me on my right side. She tells me that her name is Tonta (Aunt) Belka. She beckons me to lean over so she can whisper in my ear and this is what she tells me . . . *Silence. Allow. Follow.* That is it. Just three words. And then the dream is over. I wake up. As I sit up in my bed, I know that these three words will be my guides for the rest of my life.

But the living into these words took many years. For even though I had been given this message, I had no clue how to live a life through these words. While I believe that I have had a connection to Spirit since childhood, I just didn't always listen well. If I did listen, I couldn't always find the courage to follow my guidance.

In retrospect, I realize that you can be given wisdom way before you are ready to live from that wisdom. I didn't understand how to be silent. I didn't know how to trust myself to open to the receiving, so I didn't even ask. I thought there was nothing to receive except my own trying and nothing much came of that except heartache and disaster. There was so much pain in my life through the years, personally and professionally, that I didn't want to get close to those feelings. I was too scared to turn to the emptiness, the sorrow, and the depth of yearning that did not ever seem to be filled, for fear that I would have to make changes I wasn't ready for.

A person can live separated from self and Spirit for a long time but at some point, they hit a wall and it all falls apart. If they are lucky, that is. For it is in the coming apart of old ways that we can find the courage to create something new. Gratefully, I was lucky and, in 2008, my personal, financial and professional life hit the wall and I shattered into many pieces. I declared bankruptcy, lost my home, my private healing practice dwindled to almost nothing and my 21 year partnership ended. I could no longer stay in a relationship that was not alive for me. I had given it my all, including spending all of my retirement funds to support us. There I was broke and in great physical and emotional pain.

I lived with intense anxiety resulting in sleepless nights and a terrifying belief that I would die before I really lived.

I never knew a person could endure so much loss in such a short period of time. My home, my relationship, my colleagues, my financial stability gone. All gone.

It was then that I screamed my big questions to the hilltops. HOW DID I GET HERE? WHAT DID I DO TO LET THIS ALL HAPPEN? HOW DO I GET THROUGH THIS? WHAT DO I NEED TO LEARN? WHERE WAS SPIRIT? WHERE WAS I?

After all, I was a bright woman with a master's degree in counseling, student of many healing modalities, experienced counselor, life coach, and teacher. I had done so much healing work in my life. How did my life become such a disaster? I was ashamed that I was in such dire straits when to the world I looked so together, at least to some.

How could a person help others and still be in need of so much healing herself?

Then I remembered my Tonta Belka and her wise words... *Silence. Allow. Follow.* And I began my healing journey anew, at a deeper level than ever before. I was alone without much to do. Or, in other words, lots of time on my hands. And this journey took time. Time to be alone to FEEL, deeply FEEL. To cry and remember my life, my childhood so I could really understand the pain that I had not touched in all these years. You see, I came from a family of fear. Both of my parents came from tragic situations and they found each other. "Like attracts like," as they say. I sometimes say that our family crest, if we had one, would have a face that looked like the Edvard Munch's painting "The Scream" on it and the mouth would be yelling, "Oh, no. I am afraid of everything."

In fact, my father, whom I love dearly, used to say to me, "Let me tell you the worst that will happen." His memory of my birth is that eighty people died in a train wreck the day I was born, which was Thanksgiving Day.

Try living forward with that start.

I grew up in a context of fear and contraction. Fear of taking steps forward, fear of expanding into newness and fear of believing in something bigger. My dad was my first teacher. Through watching my dad's contracted life, I learned how I wanted to live instead of what I saw being presented to me. I had to work hard, really hard, to retrain myself into a new mindset.

And as we know, the mind is what creates our life.

I found myself attracted to everything different from my family. At age 10, I was reading *The Prophet*. I was asking myself what the meaning of life was when I was 12. I listened to folk music and the messages of social justice while my friends were listening to the Beach Boys. I created rituals for connection with Spirit in the wee small hours. I knew that there had to be something bigger than what was in front of me. Something deep, high and profound.

This yearning and hunger grew in me right into college where I studied with a professor who conducted Encounter Groups. I was one of the youngest facilitators of that process in my area. I was intrigued to learn how we grew emotionally, spiritually and relationally. But, in retrospect, I was still not ready to live fully from *Silence Allow Follow*. As a wonderful woman minister once told me, one can be in the "right house" but not yet in the "right room." That was true for me. I would remain in the "right house" but in the "wrong room" for many years to come before I realized that living from *Silence Allow Follow* was my way home to the "right room."

I got a M.S. in Counseling and tried the STRAIGHT and narrow. I married and became a guidance counselor, but I was dying inside. At 29, my first Saturn Returned, after years of trying to fit in with the regular straight world, I came out, got divorced and began to create a life that was true to me at last.

Spirit was saying that it was time for me to get more authentic in my life. It was time for me to come clean and own who I was, both personally and professionally. This was the first time I decided to live my life from the inside out. As hard as it was, and, believe me, it was hard, I knew I had to come out about my sexuality and, as it turns out, my spirituality as well.

From that year forward, I realized that my life was about finding the courage to live the life that is mine and real and authentic, in spite of what the rest of the world says or expects.

Not just finding the path to walk on but actually creating it myself. One has to be committed to the inner guidance to do that.

Throughout the years, I continued to study and learn about connecting to self and Spirit. I believe that Spirit wanted me to know from the inside out what it meant to live an authentically alive and passionate life. I tell myself that Spirit knew that I was a hands-on learner; so therefore, it was not enough for me to simply read about spiritual living. Spirit wanted me to feel it. And for my particular curriculum, I first had to learn what it was like to live a disconnected and fearful life. I have discovered that the best way to do that is to live your life paying more attention to external forces than paying attention to internal wisdom and higher connection. I kept watching and listening and feeling what I thought others wanted me to be. I was certain if I did that, I would be fully loved and accepted by all. Of course, that is not what happened.

What was most wonderful about my curriculum was that while I was experiencing the pain of disconnected choices, I was also learning, only after each wrong turn, a piece of wisdom about life, about authenticity, about myself. In looking back, I have often laughed at the lengths I went to in order to belong. One silly little example is from my early teens. I remember standing in front of my high school bathroom mirror with two

other girls I wanted to befriend. I knew that they usually talked about pimples so I looked in the mirror as they were standing next to me, and I said, "Oh, look, I have a pimple." I thought for sure I had just earned my way into their circle of friendship. Instead I got busted. The only reason I wanted a pimple, they said, was to fit in. But, too bad, I had no pimple. This was an early lesson about what real friendship really involves and the answer is, "It is not about pimples."

I learned what it feels like to be so numb and frightened to be alone that you are willing to give up your soul and purpose in order to belong. I learned what it is like to be so afraid that you will hurt someone if you live your life for real and true that you stopped living your life. I learned what it is like to wake up at 3 am and shake from fear that you will never live your purpose or contribute your gifts to the world. I also learned, now, what it feels like to find the courage and the path back to your truth. I have been to the edge and back and I know it is worth the steps needed to connect back to the song, the light and the truth of one's being.

An astrologer recently told me after my second Saturn Returned, that these 29-year cycles are the times when we are asked to let go of all that is not working so that we can create a more authentic life. The root word for authentic is the same as for the word "author." So being authentic is about "writing," or creating, your life anew each day.

In these past few years, Spirit has asked of me, in a deeper way than ever before, to let go of all that is not working for me. To let go of all that keeps me from creating a life that I want to live. Spirit is asking me to stand more fully in my own sovereignty.

Spirit spoke to me, through a dream, about this. I was standing, surrounded by a multitude of "mouths," which were

yelling at me, telling me what I should do and be. I covered my ears. I could not take it anymore and I began running far away. I ran and ran until I noticed a quiet place. I stopped and stood still. Suddenly on each side of me stood a Spirit Being. Each Being placed a foot on my foot. I began to fill up with my own essence, bottom to top. I felt my own sovereignty. As I stood in my own power, a voice from in front of me said, "Now, are you ready to take yourself seriously?"

I knew then that it was time to really pay attention to myself and to Spirit. I knew it was time to really commit to living my life from the inside out. To have the trust and faith in myself, and in Spirit, that I could create a life and a body of work that was authentic.

And what was that work? As before, Spirit helped me, through a dream, to understand my work more fully: I am standing in a rowboat. With me is a Spirit Being. We are on a calm body of water and in front of us is a line of people with their mouths open. We gently float from one person to another as I invite each person to express who and what they already are. There is no adding or fixing. There is only inviting out that which is their essence.

So my work is about educating others. "To educate" comes from the root word that means "to bring out that which is already within." I consider myself to be an educator and facilitator who helps people connect back with themselves and with their innate wisdom. I guide people to the essence of who they are and to Spirit, for without Spirit, there is nothing. Then, they can be guided to create the life they were meant to live.

All the tools, skills and experiences that I have are the means by which people can connect with self and Spirit. Through Spirit connection, I have learned that I am to work with people who have been torn asunder. Spirit said I am to help them repair. I

asked Spirit what that means because I don't consider the people of my tribe to be broken. Spirit said, "Think of the word "repair" as pairing again. So your work is to help people pair again to themselves and to something higher. They do that through practicing Silence and then Allowing and Receiving and finally Following the guidance that they were given."

I have learned that all there is in life is my connection to myself and to Spirit. I may forget from time to time. After all, I am still human. And then I'm reminded to get guidance by practicing *Silence Allow Follow* . . . over and over again. And I author my life with these three steps.

My tribe is made up of people who yearn to live their lives authentically, who feel torn asunder and separated from themselves and Spirit. My tribe feels as if they may live in the "right house" but the "wrong room" or might not be able to find the house at all.

My work takes many forms. I work with individuals, couples and families and in groups, teaching the many tools that support the *Silence Allow Follow* pathway. I also work with teams and organizations that want to function authentically so that both task and relationship are equally important.

In addition, I am a photographer and a writer of poetry. Recently, Spirit has asked me to begin offering Sharings of my writings to groups. I, also, offer Angel Card Readings as another tool for connection. My Angel Card Readings help people learn about their relationships, career and soul purpose as well as their emotional well-being.

In the past five years, I have been singing at the bedsides of people who are dying and also for their grieving families. Each time I sing, my heart opens to love and light and the miracle called LIFE. Our group is called Threshold Singers of Madison

(Wisconsin) and it is through this service that I have deepened my commitment to living fully each day that I have.

In closing, my life has been an intense laboratory where I have experienced what it means to live alive and authentically. I have learned through loss, pain and then through joy in my life. There were times I had to let go and experience intense grief and fear which were all part of my curriculum. And all of my first-hand learnings have prepared me to teach others the importance of living alive by simply being in *Silence Allowing and Receiving and Following the Guidance*. I am eternally grateful for the opportunity to support others in learning to live from the inside out so that they can find their own way of being.

Thank you and Blessings,
Vida

Creative Note: Vida is a kinesthetic processor which means she processes life and finds her words through touch, movement and feelings. She wrote this chapter as she rocked, danced and paced across her living room. She found her true voice through her deep connection with her body, as well as through her deep healing work and coaching with Anne Deidre. Her processing approach is part of the Perceptual Thinking Patterns program that she teaches to individuals, couples and organizations. What is your processing approach?

Vida Groman's Poems

64th Birthday Prayer

I stand before a portal. My feet planted firmly on the earth of grasses and small stones. I smell the air with its clarity and crispness. I stand before the portal.

All of me is here, today, this day. This is my sovereignty. Full bodied, strong standing, vibrant body standing in my Yes. I have arrived at this moment. I have shed so much, cut the chords with so many so we can all be free. Free to feel our own edges and expansions and beautiful strength born of hard work. Soul work. I stand at the portal.

There is a knowing that is growing within me. An emerging of what has been there for eons, for centuries of time, born of shadows and bends and curves of living through. Always knowing that an emergence would happen. And here it is. It was once said to me that it will be difficult until the very second it becomes easy. Well, I don't know if it is now easy, but I have turned that corner. There is the light, the uplifting gratitude to Divine Forces, unseen hands holding me ever so lovingly. Yes, I am here. I belong here and I belong to myself. And I stand at the portal.

This is my birthday, day of new birth. I am Sixty Four and I am born again. I turn toward God, Spirit, or whatever it is called, with deep reverence. I belong to me, I belong to God, I belong here in this moment as I walk through this portal to the updrafts of love that carry me high over the land where I see, see, see the vastness of the light, holding us all as it outshines the darkness of each of us so that the entirety becomes light and sacred and we reach for each other with hands from heart to touch the significance of our uniqueness and we know we are loved and alive to purpose. And we rest even as we move forward. We rest in the knowing that we belong to us, to something bigger than we. We rest, we believe, we trust. I step through the portal. I fly.
Deep abiding gratitude to all.
Amen.

Let Go

The time has come for you to let go...
Let go of it all
From the depths of each atom, each cell, let go of the chemical composition of anger, hate, jealousy, sadness, grief, fear....comparison
Let it all go
Release all that is not the Light of Knowing, of believing in the possible

There is no more to Know or do other than let go,
so that the innate quality of oneness, of connectedness to all that is Divine
can rise to the surface and spread throughout your body
Feel the goodness, the Godness, the truth of that

We are meant to open and connect-not shut down and isolate-
In all that we do, that we are, if there is no other truth, it is this....
We are meant to open and connect
For it is in the connection that we fulfill our destinies of loving

Full Circle

I sit now on a sidewalk curb....
Feeling my ear.....birds singing within spaces of silence that trees make. The silence of growing deep and tall......all in a line. The line of what is natural.

I used to sit on the stoop of my house as a young child. With a purpose....not just to sit. I wanted to make it my purpose to say hello to everyone I met who was walking past our house. It was an experiment, you see. To see how people would respond to a stranger making contact....honest, non-demanding contact.
Lives walking past my stoop, a small child saying Hi. Hello. How are you?

Oh, I got some looks.... surprise, disdain, annoyance but inside of me a deep calling was stirring. The calling to make contact with human life. To reach out and create a bond, an honest bond, even for a moment in time, an honest moment in time and leave a soft, gentle whisper of a fingerprint on someone's soul.
So my purpose started then.

And here I am today, full circle, sitting on the curb, learning still about a smile, a nod, a bow, a recognition of someone else's light. And I am taken back to my childhood, after dinner when I used to run downstairs, sit on my stoop ... wait in silence for the passing contact with life. And I smile.

Julie Hartin

*J*ulie Hartin is an author, Emotional Freedom Technique Coach, and jewelry designer who works with others to help facilitate and clear the pathway to inner peace and healing from grief so that their heart chakra is illuminated with their True Spirit of Divine Love and Light. She also works with Sacred Creativity, aligning her gifts of color and design through the creation of original jewelry pieces known as "Gems by Juel." She also takes pieces that clients send to her as "broken" working with alchemy and transformation to create something new that includes the energy of the original piece while adding new spiritual energy to it as something new and original. She also creates custom jewelry pieces from Swarovski Crystals from a client's favorite color, or images such as pink stones and butterflies or dragonflies as an example. All of Julie's healing and intuitive abilities, coaching and jewelry are a Gift, a Gem from God.

Contact information:
Email: juel19@gmail.com
To browse Julie's jewelry and treasures, please visit
www.GemsByJuel.com

The Faith in the Eyes of My Children

By Julie Hartin

As ye have faith so shall your powers and blessings be.
This is the balance.
This is the balance. This is the balance.
~'Abdu'l-Baha

When I was young, I knew who I was and I knew no one else did. I was given an inner confidence that no one knew about. People would say things of my family, of me even at times, and nothing affected me because deep down, I knew my inner confidence and who I truly was. It seemed as if had a protective shell around me that kept me from the harm of the world outside. This is the story of how I eventually came to a place in my life where that shell was broken and smashed into a million tiny pieces that fell all around me. It's a story of how, for a time, I thought I'd lost that inner confidence and even faith, how I traveled into the most horrible pit of guilt, and how I've come to realize that my inner confidence and faith were never really lost at all.

On this journey, it seems the most awesome, strong, loving and wise women I know have had the same pattern to their lives as I have. So many different struggles. But struggle we have.

For the most part, from the time I was twenty until thirty years later, I had deep inside a very solid foundation and faith. As I look back on it all, and what it was that caused me to fall into a darkness, so dark I felt I was lost with no possible way out, for I had found myself in a place I would have felt was impossible for me to go.

Today I can see clearly that I have followed a path that I had to travel. I can also see I was always led by God, from the two dreams I had repeatedly as a child to the hundreds of times I turned to God for help I felt I didn't deserve. But always, He has been there to pick me up. So lovingly proving to me that He will always forgive, comfort, and love me just as I am. I have been gifted with so many miracles in my life. I knew very early that God must have a very important mission for me to complete while here.

I got married at the age of eighteen. My husband Jack and I have been each other's greatest miracles, and also each other's greatest tests. I had just spent my teen years in the 1970s rebelling in every way. And Jack had recently returned from Viet Nam, and he suffered from mental disabilities. At that young age, I hadn't a clue what that meant. Nor what it could mean for the four children we were to have. I only knew I loved him and couldn't imagine my life without him. We both felt marriage was forever and vowed to work through life's challenges and never consider divorce as an option.

He was so different than anyone I had ever met. I had grown up in a small town in Minnesota, where everyone seemed to judge others without really even knowing them. He would never say an unkind word about anyone, a quality everyone was instantly attracted to. He was "everyone's friend" and there was something so special about him that people flocked to him like

moths to a flame. He had a light about him, like none of us had ever seen before.

You see, a few months before we met, he had returned from California. While there, he had found a religion. He was so on fire with what he learned, he wanted to rush back to Minnesota and share it with his friends. As it turned out, he quickly ended up smack in the middle of the drug and alcohol scene again. You see, he hadn't stayed in California very long, so he only learned enough that it was the Truth he had been looking for, and a few of the laws.

One thing he knew for sure was that drugs and alcohol were forbidden. So he chose to keep his new-found truth to himself until he could be an example of what he wanted to share. But at times, he couldn't help himself and I saw that every time he even thought about it, his physical being changed, and I could see the glow. I recognized it as truth and begged him to tell me more. Two months later, we married and hitchhiked out to California. We were going to straighten our lives out, and I was going to study this religion for myself. A bit ironic that we had no clue that there were hundreds of members of this religion right here in Minnesota!

You see, I had always felt a sense of truth. Many things growing up that I learned in my church didn't feel right to me. And no one could give me answers that felt right the few times I voiced my questions. For example, I saw God as loving and kind. And that He loved everyone on this earth as His own child. But I was hearing people say that you had to believe just like they did for Him to love you. Over the years, I quietly formed my own beliefs and I felt there had to be others who saw things the way I did. It was all so logical.

Well, when I finally did meet the people Jack was so excited about, that is just what I found! I studied their teaching and it

was all I believed and so much more! Although my soul knew I had found home, I was very cautious. I studied it for one and a half years before I too became a member of the Baha'i Faith. That was thirty-six years ago, and every year, I find there is more to learn.

Soon after that, a couple who had just returned from Israel came to a meeting. They had been on Pilgrimage to see the Baha'i World Center, which is in Haifa, on Mt. Carmel. They brought pictures to show us. And there before my eyes, I saw the beautiful gardens I spent many a night walking in, in my dreams as a child. Looking at them instantly brought back how I felt there. And I believed God wanted me to go forward with no doubts. And I did. He knew I had yet so many trials and lessons to struggle through in the years to come. But I walked through all of them with the firm belief that everything happens for a reason and every hardship will make you wiser and stronger if you look for the lessons.

One day when I was young, my mom asked me a question that would later prove to be such a gift "What could I have done differently, to keep you from making the choices you did as a teen?" I said truthfully, "Mom you always did the best you could. I was just trying to find my way, looking to fit in and have fun. There is nothing you did wrong."

When it came time for me to be a mother that came back to me and I wanted to know what I could teach my children so they may not have to learn the hard way. My answer became crystal clear. I had answers and reasons. I felt the most important thing I could teach them would be to have faith, and a love for God so strong they could see clearly how to live by His Will.

When I came to that dark place in my life where I was lost, I only found my way by the strength and Faith of all four of my children being reflected back to me. The thought came to me as

The Faith in the Eyes of My Children

they loved me so well, that even though I was feeling so useless, I had four children out being servants to mankind, and I must have done something right. My soul began to fight back. And the flame in me grew as I had comfort in knowing I had accomplished my goal as a mother. And whatever they faced in life, I'd helped arm them with the most important thing anyone needs.

When I got to where I could look back, I realized that as I struggled with problems that arose in life it so slowly changed me, I didn't even realize I was compromising my soul beliefs, when in reality I was struggling to do the right things. The day I woke up and saw this reality I was so brilliantly denying, I broke. I saw things completely differently and I knew at the same time, I tried desperately to right the wrongs I could no longer justify. I also had to learn to forgive myself.

During my healing, it helped me so very much that all my life I knew my parents did their best every day. I even remember wondering as a mixed-up teenager why all my friends blamed their parents for all of their woes. I knew it was not true. And I wondered what made me not blame my parents. I so clearly remember feeling it was a good thing though. As I grasped that in my heart, it helped me to see that I also had always done the best I could each day. Every wrong choice I made, I began to see how on that day, it was the best choice at that time.

Now, however, I could not turn back. I had many changes to make. During this time, Jack was in end-stage-liver failure. He needed a transplant to live and his brain had been slowly, and then more rapidly, poisoned. His liver was like a rock and all of the things it uses to filter out, it couldn't. The poisons were saturating his brain. All the darkness of his mental illness was worse than anyone could imagine. He was dying and I, in my broken state, knew I must care for him, stand by him, be his voice, his memory, and his best friend. I knew I had to put on

hold all the changes going on in my head until he got a new liver, or didn't.

Three and a half years later, he got a liver. Fifteen and a half hours he was in surgery. His body had created so many new ways to carry the blood through his body since it could no longer go through the liver. So when they opened him, they didn't know where the blood was all coming from nor how to stop it. They gave him 112 units of blood in ten minutes. They lost all vital signs for a very long time, but he made it. He was intubated and sedated for days. Any time he moved, they sedated him more as they were so afraid of hemorrhaging. We were in Pittsburg, Pennsylvania, where the VA had sent him for the transplant.

Our kids were all preparing to come out, as things looked grim. Three days post-surgery, our two sons arrived. We went to see Jack and there he was, sitting up, most of the tubes gone, with a goofy smile, not a clue why we were all in tears! Our sons and I all stood around the bed holding hands. Ben, our oldest son, had brought a picture for Jack of him and a dear friend who recently died. The second Jack saw it, our world changed.

It was as if he suddenly remembered he had unfinished business in the next world. And as we stood there holding hands, God gave me another great gift. One which to this day, more than five years later, is still impacting the course of my life.

Jack's eyes closed, tears streamed down his face. He was saying good-bye to his loved ones. His mom had died when he was eleven years old, and she rocked him and held him in her arms. He spoke to his dad, his grandpa, and his grandma, who had herself passed only three years prior. And he kept telling her, "I know it's all up to me this time, Gram."

When he came back to us, he was brand new! My sick, burdened husband who had carried the weight of the world was now so unburdened I kept feeling like I could reach over and pick

The Faith in the Eyes of My Children

him up with one hand. As I sat and listened to him, I was sure that God had answered every prayer I ever said, and we were about to begin a new life.

He said "You guys, don't worry about anything you have ever done. It's all okay because God forgave me for everything! He even showed me ways I hurt others I was unaware of. But He still forgave me, and He loves ME!"

He cried for a week as he told stories he had never before remembered. And then things took a turn for the worse as he began to hemorrhage from his spleen. His condition crashed. He fell into a coma and was intubated again. He fought for his life while we prayed and waited.

When he came out of it, his mental state was worse than it had ever been, and he had no memory of his journey in the next world! He continued to get more confused for months.

I was in shock! Why? Why did God heal him, save his life, and then send him back even more burdened? I struggled for many months to find understanding.

Months later due to my own health conditions, I was forced to separate from him. My doctors told me over and over the stress was exacerbating all my conditions and I needed to start caring for myself or I would die. It's been over three years. We are still married, forty years now. And I will always love him. I continue to look in on him, and help out some, but for the most part, he is doing well.

But in the last three years, I have learned so much and healed so much. I'm now living with and caring for my mom; it's a joy. She has been an example to me in more ways than I can tell you!

A few years prior to the transplant, I was very ill and ended up discovering EFT, Emotional Freedom Technique. Two friends had been trying to get me to try this healing method, which had

done great things in their lives. EFT is sort of like acupuncture, only instead of needles, you tap certain areas to release stuck, negative energy. It changed my life and healed many of my conditions. And my doctors at the Mayo Clinic were overjoyed at what happened to me in one weekend.

My doctor was in tears when I left her. She asked me to return in three months for lab work. I did, and the results were unbelievable! I had been in horrible pain every day and it vanished overnight! I stopped all pain meds, and my doctor said it should have not been possible. She said the withdrawal should have been unbearable. It never occurred to me to take it as the pain was gone and I was elated. As people saw the changes in me, of course they wanted to learn. I found my energy was very healing and I knew this was at least a part of my intended path.

Two months later, I spent thirty days with my mom with much help from Amy, my oldest child, caring for my dad in their home during his last month battling cancer. His wish was to die at home. It was a most difficult, yet also the most blessed, month of my life. And again, my mother's strength was to be admired.

After that is when Jack's liver got bad. My pain stayed away for two years, but slowly my energy was ebbing. I never stopped tapping; it was almost as important to me as my daily prayers. I know it helped, but three years later, I was mush. That's when my doctors first started warning me about self-care. After we got back home from the few months we were in Pittsburg following Jack's transplant, it took me another year before I finally had the courage to listen. It was so difficult, but I could see at that point we were only hurting each other.

The first thing I noticed, after being on my own for a while, was my intuition returning. Then my feelings returned. When I was able to once again feel my love for Jack, I mourned. And it was during this time that I found meaning in what I saw the day

The Faith in the Eyes of My Children

of his near-death experience. I realized God had forgiven him. And I knew at that moment that I had to as well! What a gift! My love grew stronger. But I knew the kindest way to show my love was to continue on my own path.

Also, while we awaited the transplant, my youngest daughter Emily, and my son Andy, started making jewelry together. Emily and I worked mostly with Swarovski crystals, and Andy was fabulous with chain mail. Making jewelry was my way to soothe my soul through it all and that they were involved made it that much more sweet. It still brings me great joy.

I still live with and care for my mom. Last December, I started studying to become an EFT Coach. It was fabulous and I quickly learned lessons which I will forever be grateful for.

On Jan. 19, 2014 at 11:30pm, I received a phone call from my sister-in-law, calling from Washington State to tell me my precious Amy was dead. She was 36 years old.

The next weeks and months were a journey I hope to never walk again. Amy had inherited her dad's mental illness. She hid it so well only a few people knew how she suffered her whole life. For many reasons, I am including this in my story. Most of all, I pray it will help someone else who feels how I felt.

Amy spent her entire life serving others. She had the most wonderful smile and infectious laugh. Everyone loved her—except herself. She felt unworthy, she loved God and she felt she was hurting Him. So she asked Him to take her home and she went. Two hundred shocked people were at her funeral. Her closest friends were unaware of her burdens. I knew them well.

As my heart dealt with my child taking away the life God gave her, I remembered Jack's experience. I saw my husband had been forgiven by God's grace. He had suffered his whole life and was forgiven. My daughter also suffered greatly, and I was comforted as I knew she would also be forgiven, by God's grace.

Julie Hartin

I started my coaching course again a few months later but I was not progressing with it. I felt I needed to focus on spirituality. Then I heard Anne Deidre on the Internet. I had questions and I didn't trust my own intuition at that time. So I set up a call with her. We talked. I got my answers. I felt a great soul-connection to her right away. Then she told me about the book series, *The Inner Circle Chronicles, Books 1 and 2*. She then asked if I would consider writing a chapter for the third book! I was stunned, honored, and said yes!

I went on Amazon and ordered the first book so I could see what it was like. Every story I related to in some way. Then I got to the chapter by Anna M. Nicolleti. She had a painting and a poem called *Dreamscape*. I was amazed. It was a painting of the second place I used to go to in my dreams as a child, and the poem captured my feelings! She painted a picture of my beloved spot fifty years later. So to me, God is saying, "Julie, now you know you are exactly where I want you to be."

In September 2014, all the contributing authors were invited to a retreat in Sedona, Arizona. It was tough financially. I felt if I ever did anything for myself again, I would have to do this. There I found a wonderful group of soul-sisters, and was blessed with a gift of God to top them all. At one point, we worked with each other, learning a bit about each woman's special area of interest. Anyone willing to share could. It was interesting and intense for me.

In Sedona, I was reminded of what I already knew to be true. But I had been so full of grief I was up until then blinded to rational thinking—which was that I was actually causing my Amy pain and hindering her progress. You see, I believe that when you can't let go of your attachment to your loved ones who pass on, it is harmful to them. Also, if people, while living, cause pain or

hurt others, and they leave this world, they will actually feel the pain inside of their souls, that the people they hurt are enduring.

I knew right then that all I could do for Amy was to set her free and send her love and prayers until we meet again.

Now I am going to focus on getting my business "Gems By Juel" up and going. It will consist of the jewelry I make, and vintage and antique treasures I have found. Soon I intend to add Coaching, and of course EFT. I am going to do some college this year. But I figure, whether I have a shop (which is my goal) or just sell on the Internet, while still caring for my mom, whatever people come looking for, they will find some sort of Gem!

On January, 19 2015, the first anniversary of Amy's death, our family gathered to remember Amy. We were also celebrating the birth of my first granddaughter, who was named after me and Amy. It was a day to feel more joy than grief. I thank God every day for my faith, much more now as I know, without any doubt, I still have an eternity with my Amy.

For more info on the Baha'i Faith call 1-800-22-unite or visit us at www.bahai.org

Reverend Jolie Hasson

Reverend Jolie Hasson is an ordained minister, author, Certified Angel Reader, and Certified in Arcturian and Theta Healing modalities that work with her client's energy field to release any blocks and restore them to their inner state of vibrant health and wholeness. Jolie works in person and remotely offering readings, cutting edge healing and coaching for those on the spiritual path. Jolie specializes in Sacred Activations that can remove the layers containing any and all limiting beliefs, clearing out old patterns while reconnecting them to their true Self and energy.

Contact Information:
Email: quimmly@gmail.com
Website: www.joliehasson.com
Phone: 561-767-5448

Recollections of a Starseed

By Reverend Jolie Hasson

Thinking back, as far back as I can remember, I always felt like I didn't fit in. While other children played with dolls and obeyed the rules, I preferred to play alone and thought the games children enjoyed were too "childish" and not much fun.

One of my earliest recollections was of a time when I was about four years old. We lived in the Bronx, N.Y. not very far from Yankee Stadium. I remember running away from a public playground while my mother had her head turned. I ran through the opening in the chain-link fence and was so happy to be free; hopefully I would be able to find my "real" family.

It didn't turn out that way after all. A policeman found me running down the street and scooped me up in his strong arms and brought me back to my mom, who seemed not to notice I was gone. Rats. I was back in captivity again.

I always felt unseen, unheard and unknown by my family and especially my mom. She had come to America at age nine, after surviving World War II. She had that Old World attitude that children were just to be seen and not heard. I wasn't happy with that state of affairs. All I ever heard was the word " No".

I became very defiant and argumentative, and it seemed to me that I was always on the wrong end of the argument when it came to my mom. I wish I had realized that being a Starseed, an

Indigo Scout, would give me my BS radar that always seemed to get me in trouble with my elders. The older I got, the more alone and misunderstood I felt.

When I was in school, I never spoke much to anyone. I didn't really like or accept what they were teaching me and I became increasingly unhappy that I was forced to learn things that seemed to me to be so utterly useless such as Mathematics and Social Studies.

I felt like an outcast, a misfit. My reading and comprehension levels were the highest in my elementary school and that made me a target of the bullies in the schoolyard, who heard my scores spoken over the school loudspeaker.

I really had no friends and was a loner. I felt unhappy and wondered when this would end. I never expected what would happen to me at age ten, when my mother took me to the Hayden Planetarium in Manhattan for the first time. It was a day that reverberated throughout my mind and my soul forever after.

The lights went down in the auditorium of the planetarium. There were planets and galaxies appearing on the ceiling of the Auditorium. There were otherworldly sounds.

Comets were whizzing by and stars were exploding. And then they showed pictures of Ancient Egypt, the Pyramids and the Sphinx. I had never seen this sort of thing ever before in books or on TV. Suddenly I found myself becoming distraught. I gasped for air and repeated over and over: *I want to go home. I want to go home. I WANT TO GO HOME.*

I was shaking and crying and completely hysterical. My mother hurried me outside into the hallway, trying to get me to calm down. It was very hard to compose myself. I felt so strange. I felt as though I knew for sure now that I didn't belong. I felt out of place even more than before and now there was no denying it. But how could I get back there to my "real" home?

I started going to the public library every day after school and spent hours there on weekends. I read every single book I could get my hands on in the adult book section. Books on Astronomy, Astrology, Ancient Egypt, Ancient Rome, Reincarnation, Hypnosis, World Geography and more. I kept hoping I would find answers to who I was and why I was here. And why I didn't fit in and where I did belong.

I searched for years and didn't find the answer to that enigma. Why was I here? Why did I seem so different from everyone else? I just didn't find any answers in school or in that library. I became depressed and despondent. No one understood me, and I felt more like an outcast than ever before.

One day, I just decided that there was really no answer to my questioning. No one could help me; no one cared. I decided to just give up. I didn't care anymore. I felt so alone. I just shut down. I shut down my intuition. I shut down my curiosity. I decided I had had enough. I just wanted out so I decided I was just going to coast. I would take the path of least resistance. I became a consummate underachiever. Nothing mattered to me anymore. I just stopped caring. I became a skeptic about everything. I became totally disconnected and even preferred it that way. I figured I couldn't be happy so why even try. This went on for many years.

It seemed that I fell into a deep hole of depression, especially after my beloved dog got hit by a hit-and-run driver who never even stopped. My dog had injuries to his head and leg. I had to put him down.

I didn't think I could be even more depressed but things went along like that until one day 15 years later when something miraculous happened to me. Something totally unexpected.

It was 1997 and I experienced Reiki for the very first time. I was still a skeptic but somehow I could feel the subtle pulling

sensation on my elbow lifting away years of pain and inflammation. I thought it must be some sort of trick. But there was no denying that my elbow felt much better.

I decided that this was something very helpful and I wanted to learn more. I took Reiki I and Reiki II. And I learned other forms of Reiki. I became a Reiki Master. I learned Angel Communication. I learned Theta Healing. Healer heal thyself. I got readings, healings, clearings, activations. I took classes and learned new modalities. These all helped me to realize and remember who I was. I became aware of my healing gifts and my Intuition.

In addition to my clairvoyance and my connection to the stars, I started also noticing that I was being divinely protected. Miracles would occur. Many times, I was saved at the last moment from the clutches of danger and possible death. At first, I thought it must surely be a coincidence. It happened again and again. And this also happened a lot when I was driving. I started to actually believe that I had angels and guardians from the Other Side who were watching over me and keeping me safe. It started to dawn on me that I was being protected for a reason.

And that I came here to assist others and it was not just a purpose but a true Mission.

Now I can proudly say that I work with the Angels and Ascended Masters. I do Akashic Records readings and Arcturian Healing Method healings. I read Angel Oracle cards and also do Scientific Hand Analysis. I am also a Master Sacred Activations Practitioner and Master Akashic Records Practitioner. I consider myself a transformational healer and empath who works with various modalities to bring people back to their true connection with Source/God/Creator. Every day is a wondrous collaboration between my guides and the Angelic Realm and me. I love helping people to uncover their talents, gifts and abilities and their Soul purpose.

Many clients have reported the following results after receiving the Sacred Activations:

- Your deepest beliefs may be released
- You may find yourself much calmer and happier than ever before
- If you are not living your highest purpose, you may now change it
- You may find that people are more apt to help you, they may be more kindly and friendlier
- You may trust in the Creator and know you are taken care of
- Your money fears may start to disappear

The Sacred Activations will bring up your "negative stuff," so that you may transform the negative into love, peace, abundance and health for always in the here and now.

Mission of Starseed Souls

Starseed souls on planet Earth have incarnated from other planets and dimensions to assist humanity during these times of Ascension. These souls are helping to anchor in higher frequencies, increasing the experience of Light, and higher vibrations, thereby helping those souls who have chosen to ascend from the Third Dimension to the Fifth Dimension.

Donna Kirk

Donna Kirk (born Eichorst) is a life-long Empath, Indigo Child, and Charismatic Leader.

Immediately after moving away from all the friends and family she knew, Donna gave birth to her two daughters back to back, born within the same year. During her second pregnancy, she was diagnosed with an autoimmune kidney dis-ease, Nephrotic Syndrome. That would be the spiritual sledgehammer that finally got her attention in the form of the dark night of her soul.

A graduate of the Rhys Thomas Institute of Energy Medicine, she is a Certified Energy Medicine Practitioner (EMP) offering full-spectrum energy healing sessions in person or by phone. Sessions include a discussion of the issues the client is facing and a customized energy healing. She loves helping others claim their potential and connect with their higher selves through use of the profile system she studied intensely for three years.

Donna is also an RTA-Certified Personal Renewal Group facilitator, leading self-renewal groups and retreats using the best-selling *The Mother's Guide to Self-Renewal: How to Reclaim, Rejuvenate and Re-Balance Your Life*, by Renee Peterson Trudeau. Donna's mission is to be a source of guidance and support, empowering women who haven't found their tribe.

She is called "Mommy" by the two most precious little girls in the world, Sophie and Elise. Donna lives with her husband and daughters in Milford, Massachusetts. The author is moving to Indiana in the spring of 2016.

Contact Information:
Email: donnakirk1025@gmail.com

Learning to Thrive

By Donna Kirk

I will never forget my 37th birthday. I felt something was off. That week in October of 2010, I'd been more irritable than usual; I suspected I already knew why but I had to find out for sure. I got myself ready that morning, packed up the diaper bag, and got my sweet little three-month old daughter, Sophie, ready to go to the Boston airport.

My dad had been visiting that week from Kentucky, but it was time to say goodbye. It was Dad's second time visiting us since we relocated to the suburbs of Boston, Massachusetts, but his first time in our new house. Dad came to help us get settled in; after all, it had only been a few weeks since Sophie, my husband, and I moved out of our tiny, temporary one-bedroom apartment into our permanent new home.

We made the 45-minute trip to the airport rather uneventfully, which is cause for celebration with a little baby in tow... especially as I was adjusting to driving in New England. It's quite different here, compared to the Midwest.

My first 36 years had been spent living in northern Kentucky and the Cincinnati, Ohio area, where there is plenty of traffic. I'm a great driver, with a great record. In contrast, I felt that driving in New England was like going into battle. While driving, I often felt a combination of anxiety and anger. Anxiety about all the terrible driving I witnessed on the roads in Massachusetts, and

anger about my general state of affairs. I was drowning in my own life, but I didn't bother crying out for a life preserver because there was nobody to answer me anyway. I was overwhelmed, drowning in adjustment. Adjusting to being a first-time mom. Adjusting to a very different culture in a very different part of the country. All this adjustment with no support system. No family, no friends around. The weight I felt on my shoulders pulled me below the water's surface many times. That weight almost ended me.

Sophie and I said our goodbyes to Dad at the airport, then we turned around to head back home. The battle waged on, but at least the morning traffic had dissipated. While we were out, we stopped at the grocery store close to home to pick up a few necessities. In my cart were my three-month old daughter buckled into her carrier, eggs, juice, my husband's favorite cereal, fruit, and a pregnancy test.

Happy birthday to me.

Today I lovingly say that my second daughter, Elise, is the best little birthday gift I've ever received. On my birthday, as I watched that stick develop a blue plus sign, however, I was not amused. I spent the following month in a sort of denial. I did nothing to compromise my pregnancy, but I felt less than thrilled about it. After all, I had just had a baby.

I was exhausted. I had a four-bedroom home still filled with boxes from our move. Those boxes contained our possessions I hadn't seen for almost half a year, in storage during our relocation. I wanted to be redecorating the new house, because every room needed work. So much work. It felt as if we were living in someone else's house. I suppose we were.

I did the best I could with every spare moment I had. Unpacking boxes, organizing, cleaning, painting Sophie's room, laundry, cooking, shopping, household budget, bills, and all the

domestic duties of a stay at home mom—this was my life. It never occurred to me to take care of myself. When was that supposed to happen? That whole "sleep while the baby sleeps" thing wasn't real, was it? Moms did that??? I was exhausted, but there was too much to do.

Resting and self-care never made it onto my radar. I pushed on. I was consumed by spiraling, out-of-control feelings that this life was not what I had signed up for. I'd always imagined having kids surrounded by my friends and extended family, supporting us and being a part of the family-raising process. It takes a village, right? But there I was, alone, with no village, no support, nobody. I had my husband, of course, but he was stressed and adjusting to his new position, also new to this parenting thing . . . and he doesn't exactly experience empathy for me anyway. I rarely enjoyed my beautiful baby girl the way I felt I should. The way I wanted to. And I was pregnant AGAIN? SO QUICKLY? Really, Universe? REALLY???

I did my best to focus on the silver lining in it all. I knew I wanted two children, and I'm not sure I would ever have decided it was the right time to try for a second baby. So it had been decided for me. But that is not to say I wasn't struggling.

Isolation was my way of life. My husband and I battled a lot. There was a lot of tension, stress, and general discontent. I allowed him to make me feel that I wasn't accomplishing enough while I was at home with Sophie. So I tried to do more. It was never enough.

I hadn't lost the weight I gained during my first pregnancy, about 25 pounds. About halfway through my second pregnancy, in February of 2011, my ankles became very swollen. It wasn't alarming to me; I just figured it was a side effect of the pregnancy, and I felt like a beached whale anyway.

At my next midwife appointment, my routine urine sample showed extremely high protein levels. I was referred to a nephrologist, who diagnosed me with Nephrotic Syndrome. My kidneys had become so inflamed that they were leaking too much protein into my urine, causing it to be foamy. Severe edema throughout the body is the worst side effect.

Imagine, if possible, gaining 40 pounds in one week. I have experienced that rapid weight gain three times since my diagnosis. Those have truly been the most painful, uncomfortable experiences I've ever had. The fluid puts heavy pressure on the heart and lungs so breathing is difficult, and I often felt as if I were having a heart attack. The excess fluid also disrupts the digestive system, causing vomiting and diarrhea. The skin on my right ankle even split open, because it was stretched too far, too quickly. Just as I had been.

Luckily, I responded to treatment, high doses of prednisone, and my symptoms subsided. I see now that I was so far off center that I didn't take this condition seriously enough, though. I often forgot to take my medication in the morning, as prescribed. Sometimes I remembered to take it in the afternoon or evening, which completely disrupted my sleep.

So this miserable, isolated life I led was even less tolerable on the little sleep I got, even with sleeping pills. I can only imagine how it was to be around me during this time. I detested being around myself. The prednisone caused feelings of inexplicable rage toward everything and everyone I encountered, combined with the neurological excitement of having drunk a couple pots of coffee. I was constantly hungry, completely insatiable. All this while pregnant and trying to be a loving mommy and wife.

I remained on prednisone until after Elise was born completely healthy in June 2011. At some point, I began to taper off the steroid. A few months later, the perfect storm hit me. After a

nasty fight with my husband and a bout with the flu brought home by my girls, I had another severe flare-up, which put me in the ER twice in the same week. I had truly bottomed out.

During that week, I experienced the dark night of my soul. I had been losing interest in living life as I knew it. It was during this painful, terrible week in and out of the hospital that I had a revelation, on a soul level, that it was time to decide to live or die. I had had enough—my method of operations in this life was NOT working—and I needed to just decide already. To commit, either way. To either be a victim or the victor. I knew I would rather die than continue life this way.

"Of course I want to live!" said my mind. I had two baby girls who needed me. My own mother passed away at a relatively young age from ovarian cancer when I was 33, and that had been difficult enough. So I was not about to abandon the two little souls I had chosen, and who had chosen me to be their mother. I began making better lifestyle choices in order to take better care of myself.

It was a step in the right direction, yet superficial. My body and soul were not buying into my mind's supposed enthusiasm for life. No amount of exercise, nutritional supplements and healthy foods could overcome the negative thought patterns, vows, and false belief systems etched in my energy system. I had thought and believed myself into this soul crisis.

I'm the oldest of three children. On paper, it appears that I had a good childhood...stability, parents who stayed married, surrounded by extended family, a Catholic upbringing and private Catholic education (all twelve years) that my parents worked hard to provide for all three of us. Our education was a very high priority to them.

The thing is, I've never bought into organized religion. I remember being about five years old and questioning my mom

about aspects of the Catholic faith...some about dogma. So much of it felt wrong to me from such an early age. Why would God create humans with other beliefs and then send them to hell? That's not all-knowing or all-loving. Seemed silly and counterproductive to me. But I was made to feel that I had to go along with it, just because. That is the nature of dogma--you are supposed to accept it as being true regardless of any opinions or feelings you may have of your own. I have lived most of my life this way; accepting others' thoughts, opinions and feelings as absolute truth while disregarding my own.

I tried for years to put my finger on exactly why I've lived that way...but the "why" ultimately doesn't matter. My mom was rather overbearing and controlling of me, so I learned early in life that I should just obey and do what I was told. As a pre-teen in middle school, I began battling with my mom, and we had a fairly contentious relationship until she passed away in 2007. I was always aware that she and I were very similar, yet so very different.

I turned much of my anger inward toward myself, as empaths tend to do, always arriving at the conclusion that there was something fundamentally wrong with me. I had no idea why I was so angry, why I couldn't get along with my mother, why I just didn't feel right in my own skin. Always an outsider, a black sheep, a weirdo.

I've been pretty sick much of my life. As a young child, I had numerous episodes of strep throat, pneumonia, bronchitis, coughs, and colds. Lots of nosebleeds. Allergies to what seemed like everything in the environment, then chicken pox, hand, foot, and mouth disease in grade school, depression with suicidal thoughts beginning in the middle school years, a ruptured appendix at age 13, mono at age 16.

Then during my senior year in high school, I managed to have perfect attendance. I remember being tempted to partici-

pate in Senior Skip Day . . . but I was so tired of being sick and having health issues that I was elated and proud to attain perfect attendance for once in my twelve years of school. I received many academic awards my senior year, but that perfect attendance honor still stands out for me.

I was pretty reserved as a kid, lacking confidence in myself... never feeling that I was very good at anything. I am six feet tall, but I wasn't athletic at all. However, I was (and still am) very intelligent and I have always loved reading. My claim to fame is that, according to my parents, I could read the daily newspaper at age three.

Energetically, I spent a lot of time "in my head" and I believe this is what I did to avoid feeling my feelings in my body. I had emotions aplenty, but they were repressed and often came out sideways, explosive, like combat missiles.

In my family, I never felt safe to be me. I felt like I had to walk on eggshells and conform so I wouldn't upset Mom, yet I managed to irritate her anyway. I was an excellent student, but rarely got rewarded for my work. It was just expected of me. I'm glad my parents had high expectations, but I felt pretty ignored, overlooked, and powerless when I was constantly told "no," and then my younger siblings were permitted to do or have the same thing. I worked really hard to shut down my inner rebel. She was screaming to be set free and got in minor trouble occasionally, but in Catholic school and under the thumb of an authoritarian mother, she learned that the cost outweighed the benefit. So my inner rebel remained in hiding, but I never forgot her.

At some point in my early twenties, I learned of the term "Indigo child." Suddenly, many of my "issues" made sense. I can't stand absolute authority, I am highly intuitive, empathic, and sensitive, with a highly tuned, highly accurate, and trustworthy B.S. detector. I can see right through lies, untruths, and shady

behavior, so please don't bother trying to fool me. This sense only benefits me when I trust it, however. My B.S. detector was put to good use with the opposite sex in my 20s after my fiancé and I split.

Finally able to see that I was in fact a tall, gorgeous, blonde woman, I had a lot of fun going out with friends and dating, but not taking life so seriously. That span in my twenties was overall my healthiest. I lived by myself and was free to be me, whoever that was, on any given day!

Before I turned thirty, my mom was diagnosed with ovarian cancer. Obviously it was a difficult time, but Mom's cancer was a huge catalyst for changing the way I saw dis-ease. I began to see dis-ease from a holistic view, meaning that one must consider not just the body's physical health, but that of the mind and spirit, if one truly wants to be in health.

We have doctors for the body, psychiatrists and therapists for the mind, but what for the spirit? Our society doesn't value this aspect of the self, so it goes neglected. Ultimately, we are responsible for cultivating our own spirit, which is an empowering concept--yet frightening for those of us who don't know where to start. At that time in my life, I was learning about healing concepts that would serve me later, only after the spiritual sledgehammer would strike.

To heal my kidneys, I knew I had to dig deep into my emotional and spiritual state. Self-love, self-talk, and self-care kept coming up for me, common with autoimmune disorders such as mine...and I found a workshop that helped me see how badly I'd been treating myself. This was brand new territory for me, and it's almost embarrassing now to admit how I neglected myself then.

That workshop led to me enrolling in a school of energy medicine very close to my home. This three-year program would

train me to be a certified Energy Medicine Practitioner (EMP), yet I had never, ever once, thought of actually doing energy work. Honestly I hadn't believed myself to be capable/qualified/good enough, but I was drawn to the personal growth aspects of the program. I had known most of my life that what I was doing, the way I was doing it, was absolutely not working but I had no idea how to create a shift. Even more so, that a shift was even possible. Something in the school's message resonated with me, and I knew I'd find at least a few of the answers I sought. It would be quite a commitment, but I signed up without even running it past my husband first.

Before I attended the Rhys Thomas Institute, I had spent a lot of time being someone other than myself. I never had a clue who I really was, so I played whatever role would allow me to get by, but never thrive. I simply adjusted to whatever life brought me, never once realizing that I held the power to create the life I wanted. I had been indecisive, insecure, a follower when among strong personalities, and I perceived myself as weak. I didn't stand out or feel like I mattered. I had been operating mainly out of fear, not love. Certainly not love for myself! During the very first weekend of school in the fall of 2012, I learned why I was so angry and why nothing I did seemed to work.

I was angry because, well, I'm wired to be the exact opposite of what I'd been doing. I'm what Rhys calls a "Charismatic Leader." I'm someone with a huge energy, capacity to lead groups, and the ability to inspire change in others and the world. I have a certain presence that I can use to lead by example in the light, operating out of love. The profile's shadow side is that I become an "Enforcer" when I'm defensive, operating out of fear. I have since learned how to feel who I am, aligned with my divine purpose. Conversely, I recognize the feeling of being in defense or fear, which then allows me to bring myself back to center instead

of spiraling downward, out of control, as I am prone to do. The power to get back to center has been a huge gift, beyond measure.

A huge component of the school, Rhys' profile system puts a framework around different types of people, their soul-level characteristics, and their light and dark qualities. When you know who you are and how you are wired to operate, you have the power to be authentically you. Knowing who you are is crucial to understanding your life purpose. As is knowing who you are NOT.

Trying to be something that you really just are NOT is a waste of precious energy that, when directed appropriately, guides you towards understanding your purpose. Understanding my profile has not only allowed me to know myself better, but I understand others better, as well...how to relate to them, what makes them tick, how to encourage them out of their defense as much as possible.

In my case, I had been acting as a people pleaser, which is a defense, and pretty much the opposite of a Charismatic Leader. Living life for so long with this confusion of spirit wasted my precious energy, my life force, creating lots of stress, and therefore, dis-ease in my body. I am now better aligned with my soul qualities, and my kidneys are healing. According to traditional Chinese Medicine, the kidneys are the seat of your "essence," which I interpret to be "who you are on a soul level."

It has been a tough road, but it makes sense to me now.

My experience with self-care has been a very personal one. What nourishes *my* soul will not work for everyone. Self-care is not about making sure you soak in a bubble bath so many times a week, nor is it about massage or yoga. It's about making time to do the things that fill you back up. That replenish you. That nurture you. One day, you may need to take a walk in nature, the

next, you may need to hit a punching bag. Then yes, a massage may be what you need.

The obvious self-care stuff is great and often helpful, but that's not all there is. For me, art and creativity have been sorely missing from my life. I'm finding ways to incorporate creativity into my week and truly notice when I have not done so. My soul requires it. Self-care is a matter of listening to your own self and acting on what you hear it telling you. Knowing yourself is where you must start.

Getting in touch with my own unique essence has inspired me to own my role as a leader, an empath, a healer and light worker; to own my ability to hold space for those who want to make authentic changes in their lives, and to create what I wish I had when my girls were very young and I was lost in the never ending woods of overwhelm and depression. I needed to hear that I was doing fine, that I am enough, and that it would all be OK. I wish I'd had a support system of women who accept, love, nurture, and assist in others' growth simply by being present and true to themselves. I didn't have that then, but I can be a source of reassurance, support, and wisdom now.

I am getting back "me" now. I got so lost along the way, but hindsight allows me to see the bigger picture; I have a strong desire and belief in myself that I can make an impact on this world. I know now that by being my authentic self, I shine my light, lessening the darkness, and making change in our world through the ripple effect...one soul at a time.

Jane Sapienza Lorenz

Jane Sapienza Lorenz is a coach, author, and telesummit host and producer.

After years of struggling physically, emotionally and financially, Jane found the courage to embrace her Divine gifts and began listening to "the voice of hope." First, in the creation of her apron line, CYA APRONS, and then as an empowerment coach and business mentor.

Jane works intuitively with clients to initiate the changes within in order to manifest the outer changes in every area of their lives—relationships, career, and well-being. She believes every woman deserves fun, loving relationships, vibrant health, and the money and time freedom to enjoy it all. That's the inspiration for her signature coaching program "La Dolce Vita" –the Sweet Life.

Receive your free gift—"The 7 Traits of a Divinely Empowered Woman"—at www.janelorenz.com

Contact Information:
Email: Jane@janelorenz.com
For more information, please visit www.janelorenz.com.
And for more information about her aprons, go to www.cyaaprons.com

Just Like the Tin Man

By Jane Sapienza Lorenz

I am wide awake; I can't move my body. Only my head, from side to side. On my right is my husband sleeping. To my left, my nightstand. What was once dotted with photos and mementos is now over-crowded with prescription bottles and religious statues competing for prime placement.

I try to move my arms to push the sheet off me so I can get up but I can't. It's as if it is made of cement.

I feel trapped in my body. I want to scream, as if I have just woken from a nightmare. But it's not a nightmare, it's my reality.

How did this happen to me? Just a few weeks ago I was wearing these gorgeous 3-inch heels, dancing at my cousin's Sweet 16 party.

A few days later, I was making my bed and I had to resist the urge to crawl back in. I was exhausted.

A week after that, I had an itch on my nose and I could barely move my arm up to reach my nose. I had to lean into my hand.

A few days after that, I didn't have enough strength to push down the recliner so I could get up. It took me three tries. I thought the chair was broken.

The scariest was when I was walking with my sleeping baby and my knees buckled and I almost fell. Luckily, the kitchen counter was close enough to grab onto.

But the worst part, besides the pain, is not being able to sleep. Every night, I would show Tom which pills I had just taken just in case something went wrong. I would doze for a while, only to be awakened by the pain. And, to make things worse, lying down cuts off circulation in my arms so my arms fall asleep. Over the next year or so, I will spend many nights in a sitting position on the couch just hoping for a few hours of sleep.

But for now, I just want to scream. The only reason I don't is because my kids are asleep in their rooms.

I am finally rescued. My husband helps me sit up and get out of bed. I stand there for a few minutes getting my body ready to begin my walk to the bathroom. It's only twenty feet away, but it will take me way too long to get there. What I used to do without thought now takes advanced planning. I am 33 years old and every joint in my body is stiff and inflamed. Just like the Tin Man in *The Wizard of Oz*.

* * * * *

I grew up healthy, without incident, except when I was a few months old and almost died of the whooping cough. But I lived and I don't remember it so I don't count that. And, I am proud to say, I have never broken a bone. Mostly because I was too scared to climb a tree or do anything reckless. Playing on the swing and riding my bike was daring enough for me.

I am the first born in New York to my Italian-Catholic parents, Nino and Laura, who emigrated from Sicily shortly after their wedding. My brother came along three years later . . . to the day!

I remember as a child my mom telling me stories of the saints, in addition to the classic fairy tales. I learned about them along with *Cenerentola* (Cinderella) and *Bianca Neve* (Snow White). She told me about *La Madonna delle Lacrime* (Our Lady

of Tears) and Santa Lucia, the patron saint of eyes and Sicily. But I remember *Our Lady of Fatima* was my favorite and I think she was my mom's favorite, too. Mainly because the one little girl was named Giacinta, and my brother's name is the male version, Giacinto, but we call him Jason.

I was not taught to use prayers to ask for things. You should only pray to thank God and Jesus and the saints for being so good to you. And you pray for others to get better, but never ask for anything for yourself. As a kid, when I would act up, my mom would say "Don't get Jesus mad." If I wouldn't do something she wanted me to do, she would say "God sees everything and He's going to be upset".

Did I want to upset God and Jesus? No. Was I worried? No.

That drove my parents nuts, I am sure. They could not distress me. My whole life I grew up with the belief that even when bad things happen, we should thank God because it could be worse. It could always be worse. Just stop and think of your problems. I am sure you know someone that has it much worse than you. I do, unfortunately.

"*Signore Vi ringrazio*," my grandmother Maria used to say all the time. "Thank you, God!"

My prayer now was, "Please don't let me die."

Imagine my shock and horror when I was told, at 33, that I had rheumatoid arthritis (RA). First, I had to find out what it was exactly. Then I had to figure out a plan of attack. There was no way I was going down without a fight. The problem was I couldn't even walk across a room without resting. But in my mind, I was Rambo getting ready for battle—loading the guns, stocking up on ammunition.

There were two wars going on at the time. The RA attacking my body and me gathering up soldiers to help me fight back, my doctors.

I went to my family doctor first. He ran, what a few other doctors have referred to as "the most comprehensive blood panel" they've ever seen. He could not tell me what was wrong, but suggested I go see a rheumatologist.

My husband was working for a group of cardiologists at the time and one of them was very good friends with one of the best rheumatologists around. Tom got the name and number for me to call. I called the office and made an appointment for their first available appointment—it was in three months. Within a week, my pain was so bad, I called my husband at work. I said, "I hate to ask you this but can you please ask your doctor to call his friend and see if they can get me in sooner. If not, when you come home, please take me to the hospital."

Luckily, they got me in the next day. I was so relieved. But I was still in shock. What was happening to me? All I knew about rheumatism at the time was that it's something that affects old people. One of my elderly neighbors had it. I just remember feeling sorry for her.

Around that time, a movie with George Clooney and Catherine Zeta-Jones was being heavily promoted. One scene had them in an elevator, and George had just kissed Catherine and she looks at him, all breathy and says "Is that all?"

I had seen that preview dozens of times by then, at least. But in that moment, something in me snapped. I was sitting on the edge of my bed and my eyes caught sight of photos of my kids, Ally and Steven, on my dresser. And then I saw the photo of Tom and me on our wedding day. That movie scene reminded me of what was missing in my life. It had been so long since we had been playful and carefree, so close. Echoing in my head were those words "Is that all?" I got so angry!

"Is that all?" I stood up and caught sight of my reflection in the mirror: "Is that all?" I walked over to my dresser and I saw all these cards my daughter had made me of the four of us.

Adrenaline burned through my body! I turned around and came face to face with a statue of Our Lady of Lourdes on my armoire and I yelled at her "Answer me! Is this all I get? Is that all my husband gets with me? Is this the kind of mother my kids get stuck with??"

I was shaking with rage!

I finally calmed down, wiped the tears from my face and neck and I prayed to God. I said "You better help me or else I'll make a deal with the devil if I have to!"

I was losing my mind. Lack of sleep and steroids can do that to a person, I guess.

My bedroom and my house had become a shrine. Every major saint was represented. My parents had just returned from a trip to Italy and came back with bags full of prayer cards and Jesus and saint statues, especially Padre Pio. He was the front-runner.

I had become a shell of a woman and getting worse every day!

I couldn't drive. I couldn't walk down stairs. I couldn't change my son's diaper or give him a bath. He was 18 months old. I couldn't brush my daughter's hair or walk her to the school bus. She was five. I barely had enough energy to take a shower. I was tempted to ask for one of those chairs.

But from the outside, I looked fine. I looked healthy. Well-meaning friends suggested I try this new pill, Aleve. I was taking Mobic at the time, twice a day. One Mobic is the equivalent of twelve Advil. That's like taking 24 Advils in one day and still the pain would not subside. Heavy-duty pain meds like Percoset did nothing for me, so I stopped taking them.

My doctor tried his best to avoid prescribing steroids, but my RA was so "active" and "aggressive", we had to fight back hard. Once joint damage is done, it cannot be reversed.

Every time I went to my rheumatologist's office, the waiting room would be full of older women with gnarled fingers. They would look at me and then look at each other with that knowing glance "Oh, poor thing" and I would look at them and think to myself "Oh, hell no!" I refused to become one of them.

I had all kinds of tests done: X-rays, bone density, and more, to establish a baseline. They also checked my muscle strength and my scalp for any rashes.

All I could do in those early days was wait. Wait for doctor's appointments; for test results; for the new medication to take effect; for the symptoms to (hopefully) subside. It was taking so long, I was tired of waiting.

One day, my dad asked to go to the doctor with me. Since I learned to read and write, I have been my parents' translator. "Read this letter. What do they want?" So I didn't feel the need to bring my parents along to my doctor visits. I had so much on my mind, I didn't feel like playing translator. But my dad said "Please, I want to see what kind of person this doctor is." He was worried about his daughter; it was his way of making sure I was in good hands. I obliged.

I remember my dad asking the doctor if there was anything else he could do for me. "Is there a cure?" he asked. Everyone was being so brave, but in that moment, I became aware of my dad's anguish. That broke my heart.

And just as the doctor said "No," I said "Yes, Yes, I will figure out a cure. I will get better."

The doctor looked at me as if to say, "Why are you lying to your father?" and I was like, "I am not lying."

I walked out of there and I vowed my days of doctor visits were limited at best. I put it in my head that I was going to get better and be rid of it.

Mine was one of those "invisible" diseases. I wanted to hang a sign around my neck saying, "I look healthy, but I'm not!" If I

flinch when you shake my hand, it's not because I'm being rude; it's just that my fingers feel like they'll break. If you see me driving my car to the bus stop two houses away, it's not because I'm lazy; it's because I can't stand that long.

Envy boiled up in me when I saw other women who could just jump out of their cars and walk across the parking lot.

I wanted to walk up to a door and fling it open. I wanted to grab a water bottle and be able to twist the cap off. I wanted to turn the key in the ignition without using both hands.

While I had always taken pride in my appearance, now I spent my days in sweatpants and hoodies that would double as pajamas. And forget wearing shoes. I could not even fit into my slippers, much less high heels!

I decided I didn't want to live like that anymore. The fear of the unknown—how much worse am I going to get? My excruciating pain . . . pills did nothing for me. The stress of my family watching me suffer. I had had enough! I decided I wanted my life back. Instead of talking about the things I could no longer do, I reminded myself of the few things I could still do independently.

For example, brushing my teeth. Gripping that toothbrush was impossible. A friend, who is a nurse, suggested I stick the toothbrush end into a tennis ball so then I would use both hands to grab the ball and bring it up to my mouth. I was so proud of my progress, I got a little carried away and didn't know my own newfound strength so the toothbrush slid up out of my mouth and up my nose. Not fun!

The rage began to subside. Gratitude replaced anger and frustration and anxiety.

My doctor visits became less frequent but my question stayed constant "Am I in remission yet?" The first time I asked him, he almost balked but graciously said "No." I don't blame him. I could barely walk from the stiffness and pain. But I had

made up my mind. And as the months went on and I would ask, his answer one day changed to "Not yet."

VICTORY!

He told me that in all his years in practice only a couple of his patients went into remission and they were unexplainable flukes. I made it my mission to become another one.

I am so grateful to have my health back. It truly is the greatest wealth. I have an even greater appreciation of life's simple pleasures. One of the blessings of having limited mobility was that it taught me to slow down and pay attention to what was going on around me. Unable to multi-task, I was confined to my bed or recliner and I would just watch my kids and my husband play. I can still see the three of them on the floor, laughing. Those are the memories I treasure. That is the blessing of my struggle.

People are amazed. They tell me I healed myself. I didn't know that was possible. I just made up my mind.

After years of struggling and fighting to regain my health—my life—I succeeded. And while I was aware of how lucky I was, something inside me wanted more, but I did not know what that was. Little by little, I got over my feelings of guilt and unworthiness and began to dream. I followed my heart, not my fears and doubts, and ultimately created a whole new life for myself.

I am forever grateful that I listened to the little voice that whispered "aprons." That has led me down a path full of opportunities and experiences that not in my wildest dreams would I have imagined.

To help me overcome limiting beliefs that were keeping me stuck in my apron business, I hired an amazing coach, Kris, who encouraged me to share my story of healing by hosting telesummits. That has led me to meeting so many incredible people I am honored to call colleagues and also friends.

It was while producing my first telesummit that I came across Anne Deidre. I just had to reach out to her and invite her to be a guest.

During our initial conversation, she generously shared with me so many things her intuition was telling her about me. I signed up for her Angel Card Reader certification to help me harness intuitive gifts I wasn't even aware of. And I just knew I had to be part of Book 3 of her *Inner Circle Chronicles* series.

And as a life coach and business mentor, I am honored to empower women all around the world and encourage them to pursue the desires they've been ignoring for years and create their version of "La Dolce Vita" with my coaching programs.

La Dolce Vita is the sweet life: vibrant health, loving relationships, money and time freedom, and family and friends to share them with. Heaven on earth!

I'm so grateful my prayers were answered. Sometimes I wonder why me and not others. That's why I'm so passionate about empowering others to pursue their dreams and heal themselves.

I also believe love healed me. Not only my love for my husband and kids, but my love for myself! Thanks to God's grace, I am able to enjoy all of life's pleasures again. My life is truly blessed. *Signiore Vi ringrazio!*

Lori Otto

Reverend Lori Otto is a TV show host, RMT, Psychic Intuitive, Certified Life Coach, Ordained Reverend with a Master's of Divinity degree, and Psychic Aura Reader. She works with personal clients and groups offering psychic intuitive guidance and energy work that helps rebalance their energy field and flow in their lives. Her personal readings and coaching programs will assist you in every area of your life whether it be about relationships, career or well-being.

Contact Information:
Website: www.ottoheart.com
Email: revloriotto@gmail.com
"Like" her Facebook page, www.facebook.com/LightoftheOneHeart.

My Unexpected Path to Wellness

By Lori Otto

Right around the time I turned forty, I started getting sick all the time. There were nearly continuous sinus infections, ear infections, and upper respiratory infections. My face would swell and become misshapen. I was always coughing or in pain. I was constantly on antibiotics and prescription drugs. It got so bad that they had a hard time finding antibiotics to treat me with.

When my primary care physician, who was wonderful, was not able to help me anymore, I started to see an amazing ENT (ear, nose, and throat) specialist. She suspected allergies might be the culprit and why the antibiotics didn't work, so she referred me to an allergist.

That is when the fun began. When my husband took me to the allergist, the nurse took us to a room to watch a video. It was on how the testing was going to work and how they were going to counteract any positive reactions I might have. I felt like I was back in school watching one of those silly Public Service films they used to make us watch.

After the video, we were placed in a room to meet with the doctor. He came in, introduced himself, and started to ask the expected questions. When he asked, "What do you think you are allergic to?" my husband piped in with, "She seems to be allergic to everything."

The doctor smirked and said, "No one is allergic to everything." Then we were sent with the nurse to have the testing done.

It was the prick tests that are rarely used now and they did them all over my back and arms. Can you say, "Fun!?" Not!!! Then we waited. I no longer remember how long we waited but it seemed like hours. Finally the nurse came back in and checked my results. Saying nothing, she gave me some Benadryl to take orally and put some cream on the areas where the tests were done. She then took us to a room to meet with the doctor. Again we waited.

After what felt like a very long time the door opened. It was the doctor. Finally we would get some answers! "I am so sorry," was all he said. He left, closing the door behind him. My husband and I looked at each other and said, "What the hell was that?" After waiting another ten minutes for the doctor to come back, which he didn't, we went out to the lobby and asked the receptionist for the results.

She came back looking a little white and handed us the results. The tests showed I was allergic to everything they tested for except three things. I was allergic to everything except beef, turkey, and spinach. I was allergic to every other food, animal, plant, and fabric they tested me for. We were speechless.

As we started making our way out the door, the doctor finally came back, with sales literature. Saying nothing, he handed me pamphlets for special bedding and a few other things, but nothing that gave me direction on what to do next. We left feeling overwhelmed and lost.

Back at my ENT's office a few days later, I asked her what the plan would be. As expected, I was told to only eat the three things I was not allergic to. I was also put on four different allergy medi-

cines to take every day. Did I mention four?! Talk about a living hell. And yet, I still did not get better.

Even so, I did as they said, taking the four medications every day and doing the best I could to only eat the few things I was not allergic to. My doctors were stumped. Finally my ENT admitted she didn't know what else to do for me and asked if I would be willing to try something else. At that point, I figured why not. That is when she asked if I knew about Reiki.

I said, "What the heck is that?" She didn't really know but she had a patient who was a Reiki Master and she had already referred some other patients to her. This Reiki thing seemed to help them, so I called and made an appointment. I felt I had nothing to lose. And, while I did not get better overnight, I did start to improve. I even took Reiki 1 and Reiki 2 classes so I could do Reiki on myself and my loved ones, but still the constant infections continued.

The doctor ordered x-rays to see if they were missing something. I was diagnosed with a deviated septum. At last, the answer to why I wasn't getting better! It made so much sense. How could my sinuses drain properly if my septum was deviated? I had the surgery to correct it. Still I did not get better. Then one day, my life really changed. I am not sure if it was my symptoms progressing or a result from the surgery, but things changed in a big way.

It was the end of the work day. My second shift worker came in and we were going over the day and reviewing what I needed her to do that night. Everything was pretty typical until I went to stand up. I had never felt so bizarre in my life. Things started to move and spin and I felt like I couldn't focus. Apparently I turned ghostly white, because my co-worker instantly became alarmed. I sat back down; it didn't stop.

I became scared. Knowing I couldn't even think of driving, I called my son to come and pick me up. I also called my husband at work, which I never do, and left a message for him to call me back ASAP. My husband called back just as my son and I were walking to my son's car. I told him what was happening and he told me not to leave work.

Did I mention that I worked at a hospital during all this time? My husband told me to go to the Emergency Room downstairs and he would meet me there. The ER Nurse took one look at me and had me sit in a wheelchair. She was concerned because my eyes had started this wild swinging from side to side. I went right in for a CAT scan.

While we waited for the results of the CAT scan, the ER took blood samples and did a bunch of tests. After several hours, my eyes finally settled back down, and when the results of the CAT scan came back . . . they could find nothing wrong with me. They felt it was vertigo but had no idea why I was experiencing it. I went home and slept it off for a few days, then I called my ENT and got right in to see her.

Because the ER couldn't find anything wrong with me, she didn't know how to proceed. I was sent to several specialists all over New Hampshire and Massachusetts. I had tests of all kinds and they could not find a definitive cause. The vertigo spells were coming more often and getting more severe. They would last about four hours, but it would take four days of bed rest to recover. As scary as this all was, it turned out to be a tremendous blessing.

Because I was in bed so much—and I hate being idle—I looked for something I could do in bed and still be productive. On a good day, I was out running errands when I came across a brochure for an online school. It was a Metaphysical School that fascinated me because they offered a wide range of courses. It

turned out that I knew several people who practiced various Metaphysical modalities. When I asked them if this was a good school, I got a resounding yes from all of them!

Not because I didn't trust the people I knew, but because I had never taken online courses, I also researched this school through various organizations and consumer watch groups. They all gave it a thumbs up, so I enrolled. It was the best thing I ever did. This school taught classes on everything—from all of the world's religions, to all types of divination, to business classes. That is when I came across their class on auras.

I didn't know what an aura was, but upon taking the course, I realized that I had been seeing auras my entire life. I had no idea. It thrilled me, it fascinated me, and it validated my entire lifetime up to that moment.

You see, when I was a very small child, three or four, I remember very clearly seeing colors and mists around people. I would respond to those colors by the way they made me feel. If a color was dark, cloudy, or muddy, I noticed that I felt uncomfortable around that person. The people with bright, clear, happy colors, I loved to be around. They made me feel safe and happy.

Whenever I would ask about these colors and mists though, I was told various things. "It is just your imagination," "It is steam coming off the sidewalk," "It is just the wind," and others. I was so frustrated, I didn't understand. Was I the only one who could see the colors and the mist?

All of my life, people young and old would ask me for advice. Even as a little girl, they seemed to listen to what I would say. It was freaky, weird, and exciting all at the same time. The course on auras taught me that I was seeing and feeling the auras around people. I was able to tell them things that helped them based on what I saw and felt from these auras. While it was

NEVER talked about, it finally made sense. I realized that I wasn't crazy or making it up or seeing steam from the sidewalk. I was seeing something everyone has. I was seeing something important.

Through the other courses during my studies, I learned to look at the way I lived my life. I started meditating on a regular basis, taking a more holistic approach to my health, and slowly I got better!

After I finished getting my Master of Divinity Degree from the online school and becoming a reverend, I went on to become a Certified Professional Coach, a Reiki Master and teacher, and even continued to take other aura classes. I wanted to learn all I could about this amazing gift. I learned that it can be an invaluable tool to use in everyday life. I developed my own class on auras and started teaching it locally. Now I teach others to feel and see auras, both their own and the auras of others.

I have a 98% success rate, of which I am very proud. I also use the ability to feel and see auras to coach people. It allows me to see the real them, not the one they show the world. People often hide their true selves from others and from themselves. In fact, I have found that the person people tend to know and love the least is themselves. I help them with that by reading their auras and helping them to see and understand who they really are. Auras never lie.

Because every part of your being is reflected in your aura, an aura reading can show potential areas of concern on all levels of your existence: spiritually, physically, emotionally, and mentally. For example, if you have a broken heart, the aura around your heart could be murky. If you have a knee issue, your aura around the knee may be muddy or cloudy. I take this information into account when working with clients.

My Unexpected Path to Wellness

When coaching, my clients and I come up with a plan to take back their lives so they can live their lives as their true selves, instead of how they have been programmed. This can be to recover their health, create better relationships, become more successful, or any number of other issues.

I also teach people to use the aura as a tool in everyday situations such as dating, job interviews, and business transactions. Just imagine if you can see the real person you are dealing with, you can know if this is someone you want to pursue a relationship with or someone you are comfortable doing business with. It also makes people-watching fun!

To say my life has changed is an understatement. My illnesses, going back to school, and every other aspect of this journey has forever changed the way I live. I pursue natural ways of healing, be it a naturopathic doctor, my fantastic chiropractor, healthy eating, meditation, or my daily practice of self-Reiki. I am more open minded and happy.

I am healthy now, taking no medications at all! I have not had a vertigo spell in years. I am no longer allergic to anything. If I do get under the weather, I quickly recover. I rarely see a doctor for anything more than my annual physical. My recovered health allows me to help others in many amazing ways. I am so incredibly blessed and joy filled!

I now own my own business, Light of the One Heart. I am a Certified Life Coach, a psychic aura reader, a Reiki Master and teacher, an ordained reverend with a Master of Divinity degree, and I co-host a weekly TV Show.

I work with individuals and groups offering coaching programs, aura training, Reiki training of all levels, and psychic intuitive readings. Whether it be about relationships, spirituality, abundance, career, or well-being, I can help you transform your life. I offer sessions at two locations in New Hampshire, over the internet via Skype, or over the phone. I can also come to your business to teach you and your employees to see and feel auras or provide Reiki training. Contact me and get started today!

Denise Silvernail

Denise Silvernail is the owner of Healing Hearts in Northern Utah. Using her intuition, she is able to combine her experience in energy work, counseling, and massage therapy to connect body, mind & spirit.

Denise is a Nationally Certified Massage Therapist and Body Worker, Certified Reiki Master/Teacher in Usui Shiki Ryoho, Associate Polarity Practitioner (APP), Cranial Sacral Therapist, Certified Soul Coach and Past Life Regressionist, Angel Card Reader, Chakra Wisdom Card Facilitator/Reader, Holistic Health Coach, Herbologist, Aromatherapist, and Toe Reader.

Contact Information:
 Email: info@healingheartsstudio.com
 Website: www.healingheartsstudio.com
 Blog: healingheartsstudio.wordpress.com
 Facebook: Healing Hearts Studio

The Gifts of Spirit

By Denise Silvernail

I am 25 years old and pregnant with a new little life. I have two other small children who are four and five years old. I have been to see the doctor because I have been having labor pains. It is not my regular physician and he tells me that nothing is happening and to go home to wait it out.

I collected my other children from the sitters and went home. I put them to bed and sat down in the family room to do some relaxing, but instead felt very nauseated. It was as if some sort of blackness had come over me. This continued for approximately an hour or so. I then felt as though a heavy fog was all around me. I could not move, I could not breathe, so I sat and watched as my stomach became twice its pregnant size. It would go back to normal and then grow again and again. I felt as if the baby inside of me was trying to stand up, but kept hitting my physical body. Then came a tremendous tug from inside and I watched as the soul/spirit rose from me and left me.

I went into labor the next morning and as I lay in the delivery room, a quietness fell over the doctor and the nurses in the room. I heard them talking and saying that things did not look good. Even though I had seen and felt what had happened from the night before, I screamed at the nurses and doctors that they were wrong and to leave my baby inside of me. In that moment of

sheer emotional pain, I felt that if they would just leave her inside of me, I could keep her and protect her always.

When I delivered her, I couldn't even look. One of the nurses wrapped my baby so I could see her. She was so beautiful, my little angel. I went back home that day to my little ones, and shut the door to the nursery. The pain of loss was almost more than I could bear. For days, I had a recurring dream of hearing my baby cry and me running to her, and opening door after door trying to get to her.

In the mornings, I would wake up to a tear-drenched pillow. I awoke one night about a month later to see a beautiful young woman standing beside me. She told me I was to stop crying and that I had fulfilled my contract with her. She was where she was to be and so was I. Such a beautiful peace came over me. I could see that there really is life on the other side.

I told no one what had happened. I was embarrassed, ashamed, and fearful. Thus began a time of deep depression and letting no one inside to see the real me. I could see again, my baby had opened that door, but I kept it closed. I became the over-achiever wife, mom, daughter, sister, and employee.

As a young girl, I knew that I was somewhat different from all the other kids. For one thing, my family lived in university housing in northern Utah, and I was the oldest child around. Granted I had four younger siblings at the time and we lived in a one-bedroom apartment. I guess you could say we were poor, but I didn't know it. My parents never made us feel like we didn't have the good things in life.

One of my very first recollections of knowing that something special had happened to me was at about the age of eight. My family had gone to the lake for a day trip and my parents rented a rowboat to take all of us out on the lake. My dad had rowed quite a distance and was getting ready to go back to shore, when my

younger brother stated that he wanted to walk back in the water (the lake was very shallow). He was given permission, but only on condition that his older sister (by 11 months) went with him. I was terrified of the water, but no amount of pleading changed the facts.

I was put out of the boat with him, and just as I left to go, my two younger sisters begged to go. They were given to me and we started out. Halfway to shore, one of my sisters slipped into a hole and since I had her hand, we all went down. When I surfaced, I heard my parents yelling at me to get my sisters. I still had their hands and I pushed them up, even though I myself was unable to find the ground.

I remember seeing a grown-up under the water pushing me up, and then I found myself in a standing position on the sand under the water. I know that the water was not that deep but to me it was cold, dark, and deep. I couldn't explain to anyone else what had happened, because no one else had seen the person.

My family moved to the state of Iowa for the next part of my dad's education and we felt like we had hit it rich. We moved into an old farmhouse out in the country. Coming from a one-bedroom apartment, it was a mansion. I soon discovered that this beloved home was haunted. My parents had the back bedroom upstairs and inside of their closet was a step that opened up to the attic. When we looked in there, I could see a large trunk and some boxes, but it was the little girl sitting up there with those items that scared me. I was told not to tell anyone else what I had seen, as it would scare my younger siblings.

By that time, I had another sister, and one Sunday, when she was sick, my parents left me home from church to stay with her. Being a big girl of ten, I sat on the couch quietly coloring in my book. As I sat there, I heard voices coming from my sister's room upstairs. I moved towards the stairs and found myself climbing to

the top landing. There in the room with my baby sister were lots of people in strange clothes. I ran down the stairs to the telephone on the wall and called the church. When my mom got to the phone, I was sobbing as I told her there were people in my sister's room. Mom told me to go up and get my sister while she was on the phone. I crept up those stairs, stood straight up and said "I have to get my sister."

I walked through the people, picked her up, walked back to the door, ran down the stairs, and shut the door. I went back to the phone, told my mom I had my sister. She said they were coming home. We lived twelve miles from town and that was the longest time I remember having to wait for my mom. My parents arrived to find me on the couch, rocking my sister and crying.

I went through the next approximately fifteen years pretending to be someone normal. All the while, I ignored for the most part the voices and the people I could see, hear, and smell. I learned to shut down all of those emotions that could be so overwhelming to a young, impressionable girl.

There were many responsibilities that helped to shape the person I was becoming. I learned to work hard, get good grades in school, and never be idle. I had learned that was how to block my instincts.

My family moved to quite a few different states as my dad gained an education. So upon graduating from high school, I found myself married at the age of 18 and soon after became a mother to some beautiful people. The entire time, I worked so hard to ignore all of the things that were a part of me. In a sense, I believe I had gone into depression deep inside, while building up those around me.

A few months after losing my baby, we moved to another state and I began to work for the next twenty-plus years in a hospital. It was during that period that I began to really experience

almost daily the miracles that occur in the lives of us all. It was not unusual for me to see the energies of those who had already crossed as they came to support their loved ones and those who had no earthly support.

As I began to see more and more of what was all around me, I realized that I could also see what was going on with the patients who came in to the emergency room. I began to question modern medicine in the setting I was in: where all were treated the same, given the same medicine, and no one was looking to the cause of the issue.

As I became more and more open, it became easier to see what was happening to the beautiful people I came in contact with. I became friends with a man with cancer. He was so very positive about his life and where it had led him. He came in each day for a shot and we would talk about what he was feeling and how he was that day. Then he didn't come in for about a week. I was frantic, I knew it was his time and I really needed to say goodbye to him. When he came in, I saw him right away, but he just sat down, smiled at me, and I prepared his paperwork.

I then walked over to him, sat down as he smiled and shed some tears at the same time. He said "You know." I did not say goodbye. Instead, I just held his hand and cried with him. The tears were because I was telling him who was there to greet him and that it was beautiful. It was the first time I had allowed myself to see what was coming for a person getting ready to cross.

After that, it happened more and more. It seemed like I had opened up a floodgate that did not know how to turn off. So many from the other side wanted to talk and it was overwhelming. Sleep was no longer possible and I would jump at any sound. I needed to learn how to work with what I knew. I learned that I

was in charge of this and all I had to do was to state my needs and the spirits were more than willing to accommodate me.

About this same time, I had a very dear friend tell me maybe it was time to put my money where my mouth was and go to massage school. I didn't want the traditional method, so I enrolled in a school that could teach me both massage and energy healing. I started out in school by taking just the fun classes. I sat next to one particular person each night in class.

During one of the classes, I heard my guide tell me to ask her about something called Reiki and that she would be my teacher.

I turned, looked at her, and said, "You are a Reiki Master?"

She was startled and said yes.

At the break, I asked her, "What is Reiki?" She explained and said she had a class that weekend. I told her I would be there. I had never heard of Reiki, didn't know the word, but listened to what my guides had to tell me.

I transferred schools so I could be close to my work and catch more classes between jobs. I learned about a modality called "Polarity." It is a balancing of body, mind, and spirit. I so totally embraced this concept. I knew that it all had to go together but I had never been in a place to understand or embrace this philosophy.

While in massage school, I embarked simultaneously on a 9-month study of polarity. What I discovered in taking all these classes was that I was on a path to healing me. My mantra during this time was "Healer Heal Thyself." Those words were all that I could hear in my head. Even though I was in a place of healing and seeing all of the miracles around me, inside I was still so sad.

I was so fearful that I would begin to cry and the tears would not stop. Well, they started, and I did a lot of crying. They

stopped and they started. Slowly the years of hiding and avoiding began to clear up and leave me.

I began to teach essential oils while still in massage school. I loved it all. After graduating, I continued to teach more and more classes at the school. I was also setting up a private practice and still working at the family business. One day, I looked at my family and said that it was time for me to follow my dream. I left the family business of trucks to the men, and began my own practice in the healing field. I had reached the point where I needed to be available on a full-time basis for my clients and, of course, to teach.

Working with clients on a continual basis, I discovered that I had the ability to read them. This opened up the energy in such a way that my clients were able to experience huge emotional releases. As I became more comfortable, I became aware that I was seeing beings from other realms. These beings or energies came to work with me and be instrumental in the healing of my clients. Because of my past upbringing, I was hesitant to tell clients what I could see, but I have very strong guides. Once I opened up, my client base blossomed.

I began to refer to myself as "The Last-Resort Therapist." So many people would call me saying, "You are my last resort." I had gained a reputation as being a person who could help when all was lost. Then I realized I was not a last resort, but it was that I believed in people.

I have to ability to see into the soul, to see the goodness that dwells in each of us. I believe that when we can look at someone in this manner, they can begin to believe in themselves. There is no judgment in that space. What I see is the beauty, the magnificence, and the strength that dwells within.

I have an open communication with God. I believe in the power of prayer and am open to having the guidance to work with my clients. Each of us has such diverse issues in our lives that I am willing to accept any help that is offered. I have seen miracles over and over.

One of the highs I have in life is to witness people step forward, take a look at their life, and shift it. I believe that everything happens for a purpose and if we are willing to trust in a higher source, miracles will continue to happen. It is one of the hardest things we will ever do—that looking at ourselves. Being willing to look in the mirror and love every aspect of us will propel us forward.

This summer, as I was rushing about one day, I asked that God assist me in clearing out my chakras so that anything that was no longer serving me for my highest good, be cleared out of my body. A few days later, as I was changing the sheets on my massage table, I collapsed in agonizing pain. I made it upstairs to where my mother was and collapsed on the couch.

After a call to the insurance company, they sent me to the emergency room. A cat scan and an ultrasound later, I was told I had an unexplained mass in my uterus. Off for an official biopsy first thing in the morning, and five days later, was told that I had endometrial cancer.

Within a month's time, I had a complete hysterectomy and the removal of all cancer. I was told how rare it is that anyone would catch this at such an early stage. My guides and angels love me. My work here is not complete. These were all words I heard.

I now play/work in the field of energy healing on a full-time basis. I love the work that I do and have met so many amazing

people in all phases of life. Being able to be a part of someone's path is an honor and a blessing.

I am so very blessed to have learned how to embrace the knowledge that is given to each one of us. I love the fact that every time I work with someone, he or she becomes my teacher. I totally and fully believe that each one of us is intuitive; the choice is ours. When we learn how to listen with our entire body, mind, spirit, the messages and miracles will unfold.

Deborah Lea Smith

A lifelong learner, Deborah is currently studying quantum science and healing modalities such as BodyTalk, BioGeometry and Tellington TTouch for her energy practice co-creating with people and animals. She is creating multi-media artwork containing positive energy that will be available online. She is also looking forward to being part of a group of individuals researching the validity and efficacy of energy transmissions on biofields of living and non-living materials with Mahendra Trivedi. She is passionate about visiting farmers' markets, cooking, nutritious movement, playing singing bowls for animals at rescue centers and sanctuaries and spending time with her personal and extended families and friends.

Contact information:
Email: dlsmith412@gmail.com
Website: www.DeborahLeaSmith.com

Take Flight

By Deborah Lea Smith

*It takes courage to grow up and
become who you really are
~ ee cummings*

"Can you hear me? Can you hear me? I think the helicopter door next to me is open," my friend shouted into her headset to get my and the helicopter pilot's attention. We were in a small four-seater helicopter almost three quarters of the way through our twenty-minute helicopter ride, flying above mountain peaks and through valleys.

Before my friend said those frightening words, I had finally begun to relax a little. Earlier, while my friend and I were standing in line to buy our tickets, I told her that I had a fear of heights when I was out in the open, exposed to the air. I had been in a much larger commercial helicopter as a child without a problem so I thought I would be fine for the ride. Luckily for me, my friend is a BodyTalk practitioner, a system which can help with alleviating fears and phobias. So I knew she could help me if I got really frightened.

In the past, I would have tried to suggest something else to do in my comfort zone, not wanting to reveal things about me like fear of heights. A way to keep people from knowing parts of the real me, the imperfect parts of me.

We were strapped in after a detailed safety lecture stressing the importance of keeping our cameras and cell phones inside the cabin to prevent their falling out and hitting the tail rotor which could cause the helicopter to crash.

My friend sat in the back of the helicopter and I got to sit in the co-pilot seat next to the pilot. Once I sat down, I started feeling uneasy about the clear glass floor underneath my feet and the open windows in the cockpit and passenger area even before we were airborne.

I quickly turned to look at my friend when she told us about the open door. It was definitely open a crack. The door had come unlocked so my friend was holding the door closed with one hand on the handle. She and I were starting to panic. What would happen if the door blew open and came off? I had just barely loosened my grip from holding the sides of my seat after our take off and the banking maneuvers made by the pilot.

I had not been much of a risk-taker for most of my life. For instance, I had earnestly bought into the Ozzie and Harriet way of thinking from the 1950s and 1960s, thinking I would grow up, go to college, get and stay happily married to a great guy and have wonderful perfect children. Life would be rosy and carefree. To others looking at my life from the outside, it might have looked like most of that fictitious life was true in my life but I wasn't fulfilled like Harriet Nelson. The tiny spark of the real me was not happy.

I was a stay-at-home mom when my children were little. I loved that stage of my life. Still, I wanted more. Something was missing. But what was the missing key for contentment?

I tried volunteering in the local Junior League, anticipating that this would make me more well-rounded and feel good about myself. Still, this wasn't enough either. Why wasn't being the "GOOD" wife, mother, employee, and volunteer enough after

being the "good girl" for so many years? Wasn't that the way it was supposed to be?

When my kids were in elementary school, I went back to work full time, hoping that I could find some of the contentment that was missing. Since my then-husband did some business travel, I chose traditional 9-to-5 office jobs that didn't require bringing work home or travel. I never planned on a career for myself—I thought I had one taking care of my home and family. I didn't value myself enough to pursue any of my childhood "dream jobs," which were being a nurse or an artist.

I couldn't become a successful artist because everyone knows that you can't support yourself as an artist. (How did I overlook Walt Disney as a role model with Disneyland practically in my backyard in Orange County, California?) And I couldn't be a nurse because I wasn't comfortable with doctors or in hospital settings due to the smell of rubbing alcohol.

I had my tonsils out at the age of 18 months due to chronic ear infections where I must have been first exposed to rubbing alcohol. The smell of it made me feel uncomfortable and light headed. I would get nervous about medical procedures. I had to hang my head down whenever I would get blood work drawn to calm my nerves. Once in high school, I actually fainted in a doctor's waiting room, hitting the back of my head on a table after I got a minor vaccination. (We now know how much smell is connected to emotions and memories.)

When I went back to a traditional work routine, I started to question and possibly even rebel quietly against the conservative doctrines and cultural conditioning of my family and society. We all have internalized someone else's idea of what is good. It's when we can strip off these ideas and beliefs that we can begin to create our natural selves. It often comes from pain, suffering and

hardship. Things have to change so we can grow. I started searching for things that resonated with me at a deeper level.

> *In every culture and in every medical tradition before ours, healing was accomplished by moving energy.*
> —Albert Szent-Gyorgyi, Nobel laureate in Medicine

I found out I had a keen interest in invisible energy like Feng Shui. I took fun classes where I was exposed to aura reading, remote viewing, and psychometry. I would only share what I was doing with a few friends as I still wanted to keep on my façade of the good (and normal) girl. I was very interested in my kids, art, and unseen energy that had the ability to change in people's lives.

After my divorce, I started studying many types of modalities related to energy. I learned about Geomancy from a French Druid, Feng Shui and Chinese face reading from a Chinese woman, and space clearing from a British woman. I even spent time with a woman who had the ability to trance channel an Eastern Indian woman, a Cheyenne Indian chief, and a group of "spirit doctors," a group of physicians and healers no longer in physical form. I was learning ways to positively affect people and their environments in ways I could never have imagined possible. My perceptions of what was possible for health and well-being were being irrevocably altered.

I keep looking for more ways to feel better about myself and help others to do the same. While at a network chiropractor's office, I was led to an Aura Soma practitioner who had I Ching Systems technology. She said one of their tools helped balanced the energies of people in their home.

As a single mom with two children, I wanted whatever I could find to keep us balanced. I Ching System's goal is to help people return to a more natural state of balance. They believe

that every human being has a natural pathway in life to follow, a pathway that should be fulfilling and rewarding. They believe that at the end of each life, the person should be able to look back and feel satisfied and complete, without regret or remorse.

I used and shared that technology with some of my family and friends. Two women used this technology and got themselves out of relationships they thought were bad for them.

I dodged uncomfortable situations where I had been exposed for a couple of decades, even when I moved from a city of over 200,000 people to a small town of 7,600. I sold my beautiful home with lovely gardens and quit my favorite job as a technical editor and project coordinator for an aerospace engineering firm. I moved so I could experience a small town and turn my part-time, long-distance romantic relationship into a same-city, full-time relationship.

Like diamonds needing intense pressure, cleaving and polishing to create and reveal their inner beauty, so do we need hardships and trials to allow our souls' innermost brilliance to shine.

After using the I Ching Systems technology for more than a decade, I was introduced to Mahendra Trivedi, also known as Guruji, an unconventional Indian guru who has the ability to harness an intelligent energy to transform living organisms and non-living materials.

My boyfriend gave me an energy transmission from Mahendra Trivedi as a birthday present. We went to his retreat in Chicago to witness first-hand this energy, the Trivedi Effect®. He demonstrated transmitting universal life force to inexpensive wine, transforming samples suited to each individual's palette. We were able to taste differences in the wine samples; our neighbors' samples tasting different from our own samples.

In his Healing Mastery and Healing Masters programs, Guruji focuses on the creation of a new generation of people able to utilize their thoughts to bring about a process of transformation in material objects and substances. (That some individuals are already accessing this exceptional ability foretells the dawn of a new era for humanity—an era in which the power of consciousness will be recognized and harnessed to transform our world for the benefit of all.) I joined his Healing Mastery program and my life began changing.

My romantic relationship and a part-time job ended within a few months of joining Guruji's program. I didn't know that spiritual transformation is similar to metallurgy. Internal impurities are smelted out. There can be shedding tears and feelings of doubt and loneliness that are changed to more consciousness and a deeper connection to Universal Intelligence or the God of your understanding over time. You can come to a place where you can begin to look at obstacles as opportunities for growth.

As part of the program, my colleagues and I learned we could harness this energy to bring about changes in wine and through experiments with seeds. The seeds we sent this vital life force sprouted earlier and with greater germination. They produced seedlings with longer, thicker stems, more developed root systems, larger leaves, and less insect infestation than "control" seeds, those not receiving energy transmissions. Encouraged by my seed experiment results, I began to send energy transmissions to friends, my dog Riley, and other friends' pets.

Another benefit of my participation in Guruji's program was the ripple effect, a process where family and friends began to have more positive things happen to them. For example, both of my children have gotten raises and different, more interesting jobs.

About eighteen months after I started the program, I met a student in an animal communication class who sat next to me during a lunch break from class. He told me he could feel my energy positively shifting his body's energy just by sitting next to him. (I recently had a chance encounter with him two years later at a local bank. This time he said he could feel my energy when he walked into the bank and I was standing in front of a teller's window about forty feet away from him.) Fun!

I continued in the Healing Mastery program, making friends with other participants in the program. One suggested I could deepen a connection to my higher consciousness with studying BodyTalk, a complimentary mind body spirit system designed to help our physical, mental, emotional and physical bodies communicate to the body's innate wisdom, all the way down to the workings of cells.

That seemed interesting to me so I attended my first BodyTalk course, BodyTalk Fundamentals. In the class, I met more like-minded individuals interested in co-creating well-being with family, friends, and clients. I also liked that several practitioners and instructors were conducting experiments to validate the efficacy of BodyTalk in many areas, such as chronic pain relief.

Back to the helicopter ride. After the pilot saw my friend holding the door closed, he radioed air traffic control and got clearance for an emergency landing in a deserted park. The pilot landed the helicopter and exited the cockpit, telling me not to touch anything (not likely at that point) and shut and locked the door. He got back in and with another quick call to air traffic control, we were back up in the air. A few minutes later, we landed and my friend and I were happy to feel solid ground again.

We made our way back to my friend's car. We celebrated our safe return to Earth by driving to a nearby suspension bridge that was built 230 feet above a river. We happily weaved, bobbed and walked our way over the bridge and back. It seemed so easy after the helicopter ride.

I encourage you to take risks and seek out ways to get a deeper connection to Spirit, God or whatever you call the mysterious force that connects all of us. There are more of "us" out there than you can imagine. Get ready to take-off and soar!

I wouldn't feel complete with this chapter unless I made some acknowledgements.

I am grateful to all the support I have gotten from family and friends, new and old, on this adventure of finding a more authentic me. There are many, many more people I could mention who would be more chapters in another book.

I want to thank my parents for their commitment to family holiday celebrations and great love they expressed to our family, especially their grandchildren. I want to thank them for letting my brother and me have so many pets growing up. I owe my love of orchids, home-grown fruit and vegetables, and peanut butter to my dad. I owe my love of singing and beautiful homes and gardens to my mother.

I wish to thank my children for their acceptance of my relentless desire to learn and share that knowledge and wisdom with them. I also thank them for their healthy skepticism and our trips to museums and botanical gardens.

Thank you to my friend Lauree for her suggestion about selecting Dr. Laura Stuve for my BodyTalk Fundamentals course.

That introduction has opened a doorway to places I am delighted to discover. www.bodytalksystem.com

I am grateful to Mary Miller and John Miller of I Ching Systems for their support and sharing knowledge since my introduction to their powerful tools in 1997. They have excellent tools and workshops where they offer powerful balancing technologies to get to that place of feeling satisfied with your life. (Their website is: www.ichingsystems.net.)

I am grateful to Patty and Paul Richards of the Ashland Sente Center for their support and "seeing" me. Paul and Patty Richards have a profound body of work they share in online classes and weekend workshops. The science and art of extraordinary experience. www.sentecenter.net

I am grateful to Trivedi Masters Mahendra Trivedi, Dahryn Trivedi, Gopal Nayak, and Alice Branton who have profoundly changed my family's and my life with their energy transmissions and discourses. www.trivedieffect.com

And special thanks to Anne Deidre for her recognizing me as a person interested in the health and well-being of others. Thank you for my being included in this dynamic book series.

Nancy Smith

Nancy Smith is a Spiritual Medium and lectures and demonstrates throughout New England. As a Spirit Artist, she draws the likeness of the communicating spirit. Nancy's Spirit Art is published in *Right of Passage, What the Dead say about Reincarnation* by Deborah Foulkes.

Nancy developed and teaches the program "The Akashic Journey to Soul Mastery", a series of classes about the Akashic Records of your soul. She also authored and illustrated a children's book called *Make a Magic Wish*. (Available on Amazon.)

Credentials:
Nancy carries a BFA from Rhode Island School of Design and has worked in the educational publishing field for many years as a designer. She is a Reiki Master and Teacher from the Usui tradition. She has attended The Rainbow Jaguar Institute in Peru and is a Paco in Andean Quechua Healing Techniques.

Nancy has studied under Reverend Rita Berkowitz, Brenda Lawrence, Glynn Edwards, John Holland, Lisa Williams, Christina Cross, and has attended workshops at the Arthur Findley College in England.

Contact Information:
Website: www.angelscapes.net
Email at nancy@angelscapes.net
Phone: 978-835-0005

My Journey into the Akasha
Communicating with Spirit

By Nancy Smith

*Spirit, Infinite intelligence and love,
has many ways to connect and communicate with us.
It's up to us, truly, to consciously accept and receive
that Divine connection.*

As a young child, I often felt a tremendous love surrounding me everywhere I looked and explored. I felt a wonderful optimism and trust within me. I can still remember that feeling.

I was an affectionate child. I found a picture in an album of me as a toddler hugging the stuffing out of my little cousin. My mother wrote: "We don't know what got into her." I was nicknamed "Smiley" because I greeted every person and challenge in my way with a smile.

My parents took us to church as a young family. I watched with interest as the prayers and songs glowed in colors around the sacred alter. Sometimes I saw colors around people's heads. Sometimes I heard extra voices singing with us. Much later in life, I learned I was seeing auras and energy and experiencing clairaudience.

Influenced by my Catholic upbringing, I defined this joyful presence as God, the Holy Family, and my Angels.

When I was about five years old, my parents took our young family of six kids to see the fireworks from my dad's office. My dad is an architect. His office was in a big building, many floors up. I loved riding the elevator. We pressed every button to see them light up. The drinking fountains also caught our attention, and we got into a bit of trouble as we experimented with them. The room with the giant tables with trays of pencils and expansive drawing boards with piles of papers on them was the best room of all. My dad let me climb on his very tall chair to see his very own drawing board.

The drawing tables faced a large picture window where we would watch the fireworks. My dad stood in front of the windows with his friends. They talked about the buildings they were designing. They pointed out the window, gesturing across the many lit up buildings below.

I pictured thousands of angels in and around the buildings, keeping everyone safe and sound. I then saw the angels working next to my dad and all the other architects to make new, safe, beautiful buildings. I sat in my dad's tall chair, looking at the BrightWhite board that covered his desk. I knew I needed to draw for him. I imagined a beautiful angel—*REALLY BIG*— and decided to draw her on his board so he would know the angels were with him while he worked.

I worked for a long, long time, concentrating so hard that I didn't notice anything else.

"Oooh," I heard my dad's voice behind me. "What do we have here?" My dad lifted me up from his very tall chair and studied my drawing.

My dad's desk measured about 60 inches by 36 inches and the angel filled it. The angel was a side view and she was kneeling with one knee up and one knee down. Her robes pooled around her legs and her knees, her hands were in a prayer position and

her sleeves hung from her wrists. Her face looked out to the side and her wings spread out behind her. Her gown was filled with tiny patterns and details that seemed to sparkle. Her wings were drawn carefully with every feather in place.

Behind us, I heard my mother make a sharp intake of breath. The sound she made when I was in trouble. I froze. In a flash, I realized I might have done something very bad.

"Look, the fireworks are starting," my dad said, redirecting everyone's attention to the window. I had escaped for the moment.

A couple of days later, my dad spoke to me when he came home for work. He told me, "The guys at work saw your drawing. They said that was quite an angel. They were impressed." I was so happy. I wasn't in trouble after all!

I continued to draw throughout my childhood. I used whatever I could find. Dad brought home pencils and erasers from his office and Mom found shirt cardboards from the cleaners where my dad had his shirts done. I loved to draw people the best, especially their faces.

I took art classes in school, and wound up studying art and design at a technical school in Detroit. I eventually went to Rhode Island School of Design and studied Illustration.

A few years later, when my children were still babies, I drew portraits of friends and family and eventually made a little portrait business for myself.

Then Spirit and the Angels stepped back into my life in a powerful event that changed my life.

A close friend of mine suffered a death in her family. It was actually a murder. My friend asked me to help her clean out her brother's car, which was riddled with bullet holes. He brother had been shot and passed away right next to his car. I was not prepared for what happened next.

The young man, shocked to find himself in spirit, showed up in my mind and my senses and started telling me all kinds of things about himself. Things he wished he would have done or said, things about his dad and his family relationships. He communicated with me for days. He was looking for some sense to what had happened to him, and he was looking for a way to say good-bye. I thought I was going mad.

He was so young! His family was in great pain. I did everything I could to reach past my fears to help this family. The young man showed me pictures of people he loved and then he showed me pictures of the people who shot him. He told me how and where he died. Pictures where flying through my mind and I drew them out on paper as fast as they came. I then wrote pages and pages of information and description as he gave it to me. The police took the material and examined it for a long time. Best of all, the family recognized the faces I had drawn and read his final messages. The brother was able to communicate his last words to his family through me, a brand-new medium.

I learned very quickly what mediumship was and that I was a sensitive medium. I began to study and train in the Spiritualist tradition and gained more clarity about my gifts. I learned to connect with Spirit deliberately, no longer at the whim of a situation. The divine love Spirit communicated to me touched me deeply. I felt called to continue this work.

As my abilities grew stronger, I began to pick up my pencil and paper to draw the faces I saw as I communicated with loved ones in Spirit. My Spirit Artist guides began to blend (a form of spirit connection) with me to help me create the drawings I now call "spirit portraits." At first, they were awkward drawings, but as we "got used to" each other, the drawings improved.

The following images were drawn during medium sessions.

To My Loving Sister

SV called and asked me to meet with her and her mother. We met in my studio. I brought in a woman from spirit; she had passed from cancer. I drew this picture. I did not see photos of her before I sketched her. She was the sister and daughter in spirit of SV and her mom.

Beloved

KN emailed me, asking for a phone reading. KN is located in the Midwest and was unable to meet in person. I did not have a visual of her or anyone in her life. This is a portrait of her live-in boyfriend. They were hoping to be married. He died tragically only a few months before she had this reading. I received these photos after the reading, verifying the spirit drawing.

My Loving Grandmother

BC came to my office. She had many family members in spirit. Her grandmother was the predominant spirit in the reading. I sketched "Grandmother" without seeing any photos. She had very little resemblance to her granddaughter.

As I worked with the spirits on the other side of life, I also discovered the amazing journey our soul takes from birth through life and back to Spirit again. I became more and more aware of the love from God, and energy of compassionate love. I learned about Akashic Healing Love and the journey of a soul through its own Akashic Records, a kind of book of life.

> *Akasha is a Sanskrit word and means primary substance, that out of which all things are formed. It is the first stage of crystallization of spirit... This Akasha, or primary substance, is so sensitive that the slightest vibration any place in the universe registers upon it.*
> ~ The Aquarian Gospel of Jesus Christ

Within the Akashic field of energy is a library of information and the wisdom of all creation. The Akashic energy is sensitive and all events are impressed and embedded within this Akashic library of records. The records contain the macrocosm and microcosm, the big picture and the very personal information is all retained in this Akashic field.

I find it easy and satisfying to read for people from their Soul's journey as I connected into the Spirit side of life. As I read, I feel a strong angelic presence that guides me and helps me clarify the messages I give. I began to offer Akashic readings for those who wanted to focus on their own Soul's journey through life. My clients who chose this reading often left with a clear sense of what was truly going on in their lives. During a session, Spirit often gave homework and tasks to focus on so clients could continue to uncover their inner soul's magnificence.

Agape, or **Akashic Spiritual Love**, is about our connection to our spirit, our soul, and the Creator. (Infinite intelligence,

love and light). This is a reciprocal relationship. This love speaks to a constant influx of spiritual "energy" that sustains our etheric, emotional, mental and physical bodies that combine to create our self in this life. This is not religious love. This love is the basis of the mystical essence of all religions, but in itself is **not** a belief system. ***It simply IS.*** This is the "quantum field," or the ***Akashic*** essence of creation, where all potential exists and from which all creation is born.

As I worked to reveal Spirit and the wonder of our Soul's Journey to my clients, I found I came to a point in my life when I needed to allow Spirit to show me how much they loved me. I always pray to be at my best and highest for the work and calling from Spirit as I read for the people that came to me.

Then one day I found out I had breast cancer. The dance with cancer slowed me down and compelled me to look within for strength from myself and from Spirit and then direct that strength towards loving myself.

While I was going through treatment for cancer, I took time to draw the spirits I felt around me. I was asking for support and healing from Spirit. I drew a portrait of a beautiful woman with a scarf on her head. I felt she had gone through what I was going through, and ended up passing from the cancer. She told me she was there to help me. Together we faced my fear of possibly losing my life. I felt her give me courage to endure the pain of the treatments.

Months later, I shared my sketch book with my students in a spirit art class. One of the students recognized her face as her aunt who had passed from cancer. My student described her aunt exactly the way I felt her when I drew her. I was speechless and moved to tears. This woman in spirit had helped me gently, quietly, and with much love. Spirit is amazing and often works in very unexpected ways. I feel so blessed.

*This lovely woman made herself known
to me from Spirit and sat with me
as I rested and healed.*

The Angels and my loved ones from Spirit were also making themselves known to me, to help me. On the first day of radiation, I woke up when I felt something hit my head. I was dreaming that a penny was falling from heaven. I was a bit dazed and then it occurred to me—my Aunt Penny! Aunt Penny had passed in 2008. I didn't often hear from her, but that morning, she was waking me up to get ready for radiation. She was going with me!

Later, while I was under that huge machine that looked like a space ship ready to take off for Mars, I noticed a funny outline around the walls and ceiling behind the machine. I kind of squinted and it seemed to be the outline of an Angel. I heard (clairaudiently) "Archangel Raphael" and "I am here. Let's pray

together for healing." I felt calm replace the anxiety I felt. I was really scared of the big radiation machine. I asked him to give me words for a healing prayer. We prayed:

> *Mother, Father, God Creator of all that is*
> *and the Akashic energy of unconditional love*
> *Align me with the Angel's vibration*
> *Of love and well being*
> *In my body, in my mind, in my emotions*
> *So that I may know God's love*
> *And become whole, healed and filled with life*
> *On every level: from my bodily cells to my Soul.*
> *Amen.*

For God so loved the world....

The presence of God is Love. God is Love. Love is the Energy used in all the creator's creations. The **Akasha** is the essence of the Creator's source and IS that energy of Love.

When we return to "God," whether it is during this life as we live it or as a result of transition of death to Spirit form, we return to love. Illness, disease, and loss are often a call from our Soul to redirect our lives. When we direct our minds, emotions, and spirit to self-love and accept a divine, loving, healing presence in our lives, miracles can happen. They aren't really miracles outside of nature. We are meant to live our lives in love. It's that natural way of living that brings us back to health and a sense of well-being. **The miracle is our return to love, back to Source, to God.**

"Love" is key to our emotional, mental and spiritual well-being. As water is necessary for physical sustenance and even

survival, so is love necessary for our mental-emotional balance and ability to thrive in our lives.

Self-Love is a relationship with our self. This love is about how we see our Self, how we care for our Self and how we honor our being. We NEED to love ourselves. I have learned that the times I am patient and treat myself gently, I am more likely to feel the presence of the higher power of Spirit.

Remove the resistance you have towards loving yourself. Our self-awareness and our ability to recognize our needs and care for our Self is in direct proportion to our capacity to receive God's love. God's love (Akashic Energy) is an energetic flow of healing, nurturing love. A good way to open to this flow is to open your heart in meditation.

Try this heart meditation. I often open my groups with this meditation.

Making it REAL

Heart Meditation:
Sitting in the presence of Akashic Love

Set up: A quiet, comfortable place where you won't be interrupted. Create a safe place for yourself that you can return to whenever you want to. Make this place an actual spot in your home and an "inner" place in your heart and mind using your imagination.

Time: 10 to 20 minutes

Download (optional) an audio file from:
www.angelscapes.net/meditations

Make some agreements with yourself:
This place is timeless, take all the time you need to be on this healing path.

Blame, shame, guilt, or self-judgment are not welcome. You are safe within this circle.

Open your circle with your Akashic Journey prayer if you have one, or simply set the intention that this is your circle of calm and connection to Akashic Healing Love.

Simply Breathe
The best place to begin your journey is right where you are, just as you are. Open your awareness and your heart to YOU. Breathe deeply, in through your nose and out through your mouth, and with each exhale, let your body relax into the moment.

As you breathe in, breathe into the center of your heart. Imagine with each breath your heart is being filled with a calm, loving presence. Imagine the energy center of your heart is growing larger and larger with each breath, until you are sitting in the middle of your heart's energy.

Imagine there is a door within your heart. This is a door to the center of the Universal Love and Life Force of the Akasha. Allow your heart to blend with the Unconditional Love of the Creator.

As your heart center grows larger, soften your thoughts and let them drop into the center of your heart, so that every thought is heart-centered. If a worried or unpleasant string of thoughts arrives, breathe into those thoughts and let them blend into your heart. As they blend into your heart, they will begin to transform. Observe what happens to them. Watch as they transform into an expression of self-love. Remember these messages.

Continue with this breathing practice for as long as you choose.

Toward the end of the session, jot down your messages of love.

Close your session with a prayer of gratitude.

Eva Thompson

Eva Thompson is a certified angel card reader through Anne Deidre and Inner Visions Gallery, LLC. She is a lifelong clairaudient and clairsentient intuitive. She has a B.S. degree in Mass Communication from Boston University and a dual degree of B.S. in Health Science/M.S. in Physical Therapy from Mercy College in Dobbs Ferry, New York.

Eva is a certified personal trainer through the Aerobics and Fitness Association of America (AFAA) and has been working in Health & Wellness continually for over twenty years. Eva's passion is to help others find the balance in their lives through mind-body-spirit wellness that leads to a life of joy and fulfillment. By bringing together her knowledge of the physical body and her intuitive abilities, Eva strives to help her clients to feel strong and healthy in all aspects of their lives and to set and reach their personal goals.

Contact Information:
Email: evathompson538@gmail.com
Website: www.spiritualguidance444.com

Overcoming Fear

By Eva Thompson

The breeze caresses my cheek like the back of a loving hand, and I close my eyes to go away. For a brief moment, I am both soothed and strengthened by the sun's warmth hugging my small body and filling me up. Then I open my eyes. And I am empty. I want to cry, but I am numb. A familiar chill starts to creep over me, tugging at the tiny hairs on my pores. My jaw is locked. The door has slammed on my moment of escape.

This is the day I decided that my secret had to stay in the emptiness that I held deep within. I vowed to myself on that day to never reveal my secret because I did not want to hurt my parents. As we stood outside that sickly yellow house on that beautiful autumn day, my mother and I were both very alone. She cried outwardly as I had never really seen her do before, and I stood frozen, unsure what to do.

I was frightened by my mother's sadness and loss of composure. She was always so strong, and I relied on that. In that moment, I concluded it was my pain or my mother's, and I could not bear to see my mother so sad. If my mother knew my secret, I was certain she would be very sad and very disappointed in me. I drew in a long breath and dove down deep into myself to hibernate my feelings for a long, long time.

My mother was so enveloped by her grief that she must have assumed my sadness was about her friend dying, too. Even at nine years old, I had a logical nature that allowed me to justify to myself the ambivalence I felt about my mother's friend's passing.

I did feel some sadness, but I was also scared, angry, and confused about the situation I had witnessed moments earlier when my mom and I stood at the foot of her friend's bed and silence hung heavily in the air around us.

The lady in the bed was shrunken and shriveled, not vibrant and full of energy like the lady I had known for many years. Her knowing eyes had little light left and she only glanced at me, barely able to hold my gaze. Except for a few spider-leg-like hairs touching her scalp, she was bald. Her pale skin looked white and sticky, and I was afraid to get too close. There I stood, clinging to the bed frame, while my mom and her friend exchanged a few surface words, trying to sum up their years of friendship in a compact package of sentences and smiles.

I sensed the tragedy of this lady's life being slowly pulled from her body as she lay small and devoured in the bed of white sheets, as if she were resting on a cloud. My heart ached for her; no one should have to suffer this way. But she knew my secret, and she never tried to help me. She could have saved me from her son's unspeakable behavior, but she did not. I carried a lot of anger toward her for that, so it was hard for me to feel much sympathy for her.

Conflicting emotions were a theme of my childhood. I would have moments of happiness, but sadness, anxiety, and anger weighed me down. I didn't want to feel these negative feelings, but they were always there. My nightly dreams alternated between falling through the sky with no parachute and drowning in water followed by waking up in a sweat. Anxiety weighed me down all the days of my preteen and teenage years.

Holding on tightly to my secret helped to fuel anger, too. I had been hurt and no one had saved me, so I was angry about

Overcoming Fear

that. Every time, before I had to go to his house to visit the family, I would cry and panic and make up excuses not to go. I was mad that no one read these clear signs of my trauma. Instead, I was told to put on my shoes, get in the car, and be social. I didn't want to be angry, but I didn't know how not to be upset.

During those young years, that series of events defined me. I had allowed that horrible time in my life to replay over and over in my mind, thereby giving it and him more power over me. Clinging to my secret felt like the only control I had. I really was afraid that if I forgot about it and released its memories and effects from my soul, it would be as if it never actually happened. And it seemed so important to me then to not let that happen because it would be letting him get away with it.

In reality, I was only hurting myself by holding onto the dreadful memory. Now, looking back, I can see clearly that anger and fear were my only coping mechanisms. And they were not healthy. I didn't speak up about the molestation until I was 17, when I told my mother. She told me to forget about it. That made me feel more upset and abandoned. The idea of forgetting what had happened made me feel less in control and only perpetuated my anxiety.

I was the baby of my family. I was the one whom everyone felt needed to be protected. I grew up knowing I was loved, yet I always felt incompetent and not as smart or capable as everyone around me. I lacked self-confidence. My parents did a lot for me, and they were wonderful examples of selflessness, kindness, and strong work ethic. In their love for me, they did so much for me that the only role I knew how to play was "the baby."

Often, important family situations were kept from me because they thought I probably couldn't handle things or was too young to understand. I was an honor student, I was obedient, I tried hard to always make my parents proud, and I went off to a good college. I graduated from college early and moved in with

my boyfriend who soon became my husband. He took care of me. I went from my parents' protection to his loving arms. I was always looking for shelter from the storm of anxiety that raged inside me. I thought other people could provide me the comfort I needed. I did not believe or even consider that I was capable of helping myself.

My earliest memories of my own childhood are clear with my worry over everything: the dying flowers, the squirrel who might not have enough acorns that winter, the "what ifs" of every possibility . . . and the dependency on my mother. I clearly remember my mother telling me "You can't save the world, Eva." Oh. Okay then. I'll just keep worrying about it. And so I did.

Oftentimes, I would hear clairaudient messages with guidance about something I should or shouldn't do, but I ignored them and never told anyone because I lacked the confidence to believe that what I heard and felt could be true, meaningful, or important. I distinctly remember my mom predicting events before they happened or saying she needed to call a certain person, and the phone would ring with that person on the other end of the line. I believed my mother had some special "powers" that I didn't understand, and I thought she not only knew the answers to everything—but could fix everything.

I guess many people feel that way about their mothers—that they are superheroes of sorts. In my case, I felt I couldn't exist without my mother. I was dependent on her for answers and wisdom, because I didn't know then that I, as we all do, had guardian angels to guide me. I also did not understand then about the Law of Attraction, and that the energy I put out is what I would receive in return. At the time, I couldn't see that clearly because my entire psyche had been imprinted with fear that was woven into all the facets of who I had become.

Fear became a negative entity that had taken over me on all levels: spiritually, physically, mentally, and emotionally. I honestly did not know where I started and fear began. It—I—was

Overcoming Fear

all one big blur. After years of fear fueling my daily life and having been a physically strong and healthy child, the physical symptoms began. Panic attacks, stomachaches, headaches, dizziness, tingling fingers and toes . . . I was convinced I must be dying. So I worried about that.

In the last quarter of my 8th grade school year, I was cornered by a group of girls, some of whom were supposedly my close friends. They said they hated me, and they bullied me for the last few months of school. Their "hatred" of me added fuel to the fire of fear that constantly burned inside of me.

Being a quiet, submissive child by nature, I didn't fight back. I was a perfect target for these mean girls. Their emotional torture gnawed at me like a wild animal chewing a bone, and I was sick every morning before school started. I began having panic attacks multiple times on a daily basis, and I felt so isolated that I contemplated suicide. But when it came down to actually going through with it, I pictured my parents finding me on my closet floor. That was too much to bear because I did not want to hurt them.

I remember feeling so out of control with my body and mind, and I wonder how I maintained honor roll in school. I must have been determined and smart, but I did not have positive thoughts like that about myself then. Looking in the mirror, I saw every physical trait as being wrong with me. I never even considered that I had intelligence, inner strength, a kind heart, or any other worthy character traits that could not be seen in a mirror. All I could see was my outer shell.

Eventually, because my breasts developed early and were very large, I was embarrassed and those cruel girls would tease me and say nasty things about my body. My parents suggested breast reduction surgery. I had never heard of that before, but I wanted to escape my body and the emotional pain.

By the time I got to age 16, men would leer at me and say sexual things to me, and that caused me to feel more disassoci-

ated with my body. And fearful of being sexually attacked. So I agreed to the surgery.

The night of my surgery, I was lying in the hospital bed and heard a clairaudient message very clearly telling me not to have the surgery. At that point in my life, I was still pushing messages away, not understanding their source was the Divine and not trusting my own intuition. Besides, I was too afraid to call home and cancel the surgery. After all, that would disappoint the surgeon, my parents, who knew who else—and I couldn't bring myself to upset someone else or do the "wrong" thing.

There was a huge disconnect for me between my physical and spiritual self. I ignored the strong message and had the operation. The surgery was a temporary fix. For a while, I felt better and could portray myself with a bit more confidence in the clothes I could wear, and I held my usually rounded shoulders back a bit more. However, I still did not feel whole. The surgery had not fixed me. Fear was still in control.

My mother always told me not to worry so much, that no one else in the family worried like me and I should stop it, but I couldn't seem to shut off the fear. It just kept flowing like a broken faucet that wouldn't close. Fear was like a form of water torture, dripping negativity into my subconscious, telling me negative things about myself.

The fear took up residence in my soul where self-love should have lived. Fear had become so all-consuming that it drowned out any other feelings or coping mechanisms. When I fell in love for the first time at seventeen years old, the clairaudient messages returned, like breaking through static on a radio station as my heart and soul began to re-open.

This was a revelation for me: Love is more powerful than fear. My mother told me I was too young to know what love is, but for the first time in my life, I trusted my intuition and felt certain I knew what I felt was real. No matter what anyone said. I clearly remember standing in my then boyfriend's backyard

Overcoming Fear

watching him kick a soccer ball while the sun shined down on his hair and he smiled at me. My heart felt so full I thought it might burst, and then I heard the message "This won't last long enough for you." This was proven to be painfully true when a few weeks later, he broke up with me because he wanted to date other people when we both went off to college.

In college, I taught aerobics at a fitness studio part time, and as I gained physical strength I felt empowered. I began to feel grateful for my strong body. I also felt rejuvenated (and temporarily forgot about my own worries!) when I was able to help others with their physical fitness and make their day brighter. The level of fulfillment I felt when helping others confirmed to me that my life's path would involve helping other people lead healthy lives.

Then I hit a speed bump. After the birth of my first child in my early twenties, my body began to shut down, and I truly physically felt like I was dying. I went from the peak of physical fitness to a week away from a coma. My mother was the only one who believed me when I explained my symptoms, and after several months of seeing many doctors and suffering with slowing heart rate and crushing fatigue among many other troubling symptoms, a doctor diagnosed an autoimmune disease. It took this illness to push me onto the path of holistic healing because when Western medicine helped me to a point and then stopped short, I was forced to look elsewhere for a solution.

I took the medicine prescribed by the doctor, but I still didn't feel "right." Doctors kept telling me to just take the medicine, and all would be well. They were not hearing me or taking my complaints seriously, and this only fed the self-doubt and my feelings of incompetency. If the highly educated doctors said I'm fine, well then, what could I possibly know about my own body?!

After connecting with a group of holistic mothers and forming a playgroup for my two small children, I began to learn about holistic methods—remedies that existed in nature—that I

could use to help heal my physical body. After finding great success for myself with natural medicine, I began to use herbal remedies to help strengthen my children's immune systems when they caught a cold and topical homeopathic oils and gels on bruises, whole food vitamins, and much more.

Finally, I could clearly see the correlation between the chronic emotional stress that overpowered my childhood and my physical illness. I finally started to see the Law of Attraction at work! I realized that the Universe wasn't judging me and never was—I was getting back what I was giving out on an energy/vibrational level, seeing the results manifesting in my physical body!

Mind-body-spirit balance for total wellness finally made sense. Good health was not only based on the physical body. This revelation confirmed that there was a deep interconnectedness of the physical body and emotional wellness, and I could clearly see how imbalance led to illness.

A few short years after I started to feel in control of my health again through clean nutrition, physical fitness, and integrative medicine (combining Western and Eastern medicine philosophies and treatments), my mother was given a terminal diagnosis of Stage 4 metastatic breast cancer. I felt like I had been punched in the gut and couldn't breathe, and I began to emotionally unravel.

I went to Stevan Thayer, a holistic health practitioner who created Integrated Energy Therapy, out of desperation to just function. I didn't know what IET was, but I was willing to try anything to feel physically and emotionally better. Immediately, I felt safe and protected in the presence of his healing energy. This amazing gentleman told me he worked with angels and had one in particular, Ariel, who guided him.

This experience was my first conscious communication with angels, and something deep within my soul was awakened. Angel Ariel recognized my need for a sense of control in an out-of-

Overcoming Fear

control situation, and she had the practitioner give me a Reiki Level 1 adjustment to help ease my mother's pain. I didn't fully know what Reiki was at the time, but I was so grateful to feel empowered to help my mother in any way possible.

After the session ended, Stevan told me that any time I touched any living thing (plants included!) since my Reiki adjustment, my hands would get warm. This meant that Universal healing energy was flowing through me. Wow, I suddenly felt strong and capable. After that, when I visited my mother at the hospital and placed my hands on her head or wherever her pain was at the time, she would tell me it felt like a heating pad was on her and soothing her. She thanked me. I thought I could heal her and was excited to have this healing ability.

A few weeks later, at age 57, my mother died. I felt so alone I couldn't get out of bed for two days. In my twenties, with two small children, I was still like a little child myself so dependent on my mother's love, guidance, and approval. She was my lifeline. I didn't know how to live without her or who I would be without her being my mirror to reflect back to me who I was. So began a spiritual journey of coming out of the darkness of fear and into the light of self-love and understanding. It took me years to forgive myself for not being stronger, for allowing fear to control me, for having faith that my mother's untimely passing was part of her soul's journey.

My physical body was healing and now it was time to dig deeper and heal my spirit. I was afraid to begin to look at the mess of emotions that was inside me!! My husband's strength dragged me through the beginning of this spiritual journey, and I will be forever grateful to him for giving me the tough, yet tender, love I needed. He told me to get out of bed, that I could do it.

This was a new concept for me: *I could do something by myself? No one is going to help me?* I didn't believe in myself yet, but for my husband and children, I got out of the bed and started to live again. I wouldn't have to go it alone. Angels were with me, right where they had always been! The difference was that now,

with fear fading into the background of my life, I could more clearly hear their Divine messages.

Almost immediately, the clairaudient messages were back full force. My mother and my maternal grandmother both visited me from the Other Side and gave me specific guidance and loving messages. I was pregnant again with a baby girl whom I would name after my mother, and my mother came to me in a specific dream and held her namesake in her arms. In the dream, I began jumping up and down with excitement at seeing my mother, and she looked at me so slowly and robotically and said, "Human beings are so two dimensional, Eva."

Immediately, I understood what she meant: She was always with me even when I couldn't see her or feel her in the third-dimensional world. This was true for all loved ones who had passed on out of their physical bodies. I didn't tell anyone except my husband about the messages I was receiving for fear of judgment and ridicule from others. Without my mother's physical presence to ask questions of and seek approval from, I looked inward and trusted myself. I suddenly understood something unfathomable to me before: I have an unlimited amount of strength inside me to deal with any situation.

Two years ago, I took my oldest daughter to a holistic health fair to help show her some natural ways to achieve peace and good health that involve natural medicine and spiritual growth. In an ironic turn of events, after scheduling my daughter to work with Anne Deidre, an intuitive catalyst coach, she could not keep the schedule so I asked Anne if I could train with her. Anne helped me awaken and accept my intuitive gifts that had been right there with me all those years of my childhood.

The Universe had other plans for me to help my daughter-- by helping myself first. As was typical for me, I thought someone else—in this case, Anne, would show my daughter what to do and how to help her. Someone else must know better than I do what to do.

Overcoming Fear

Not anymore. Anne became the first person I encountered who saw my complete, true Self, encouraged me to follow my intuition, and listen to the spiritual messages. Anne showed me that I was enough just as I was. I could help my daughter by following the Divine messages I received. How could this be when I had always doubted myself? It was a new perspective, like putting on a pair of glasses when my eyes couldn't focus, but it was spiritual glasses. I liked it. Yes, I liked it a lot!

As if the sun broke through the clouds after a deluge of rain, I felt lighter and almost giddy that I could be happy and could love myself and count on my abilities and not only was that okay, but that was how people should feel! I finally had achieved a feeling of consistent joy by learning to release fear and live in the vibration of love. I wanted to share this feeling with everyone I met.

This realization reminded me of when I played Dorothy in my elementary school's fourth grade play. Suddenly the message that Glinda, the Good Witch, tells Dorothy was powerfully present in my life. Glinda tells Dorothy all she has to do to go home is click her heels because she's had the power inside her all along! In the same way, everything I need to live out my life's purpose I came into this world with when I was born. Each one of us is innately equipped with all we need to live our best life.

It has taken many years, but I now listen intently to that intuition. I focus on what I feel, what I "hear," what I see in my mind's eye, and what I know to be true by what resonates with my soul. This connection with my soul has helped me achieve the sense of wholeness I have longed for by allowing my mind and body to exist in harmony. This helps me to look in the mirror and see my inner beauty shine through.

Over the course of my adult life, I have worked in health and fitness, guiding people onto the path of wellness in their lives. I work with people holistically, helping them to balance their mind-body-spirit. It has been my experience over twenty-plus years in

health and wellness that our struggles with changing our physical bodies starts with changing our mental perceptions of ourselves. Sure, we can do a variety of physical exercises, but without a mental reset to a self-loving view and a spirit open to following our own intuitive guidance, we can easily be distracted off our life's path and happiness can evade us.

The ego is so powerful, and it has a way of making us question ourselves. My advice is to not doubt yourself. Go with your first instinct on things, follow your heart, try to send others love even when they are mean to you (I still struggle with this one, but I know this is the best thing to do!), know your worth and that you are beautiful and worthy of every form of abundance on this amazing Earth. Spread love: Love is a fear eraser.

I took an angel card reading certification course with Anne Deidre, and it was overwhelming to me the number of messages I received each time I did a reading. I felt almost a sense of relief, like my guardian angels were thinking "She finally acknowledges us. She hears us!!" Of course, at first I struggled with saying everything I was hearing and feeling, but Anne gave me the confidence and support to share the messages without doubting myself.

So no matter what messages I receive, I pass them on. Most of the time, I don't even fully understand what the message means to the person I am reading. But I trust in the Divine, and I see the understanding on people's faces or hear it in their voices, and that's what matters most. I am able to be a messenger, bringing Divine love and guidance to people as needed. I often do readings over the phone, so I am not even seeing someone, so I can't read body language either. I actually prefer that. I love to read complete strangers because my ego mind has no preconceived notions of who they are, what they want, what they are struggling with, and so on.

With Anne's encouragement, I have set up a website to offer my services of angel card and intuitive readings. This took some gentle guidance by Anne, but she patiently and lovingly reassured

Overcoming Fear

me that something that feels so fulfilling to my soul is a good thing to pursue. It's definitely not easy to walk a path outside of the norm, especially since my family is filled with doctors, lawyers, teachers, and so many highly educated and accomplished individuals who I have worried may not understand my path. However, I hope to follow my heart and let happiness lead me rather than any negative emotions such as fear or worry anymore. For the first time in my life, I am being who I want to be and doing what I want to do, not what I think other people expect of me. I finally feel like my body, mind, and spirit are in synch, and I am as whole as I have ever been. I am finally being brave, and by sharing this story with all of you who felt guided to pick up this book, I am being honest about my journey and some of my struggles. I hope that it helps you to know that you, too, have the power of intuition, the love of the Divine, and guardian angels to guide you. I would like to show others the way to this joy also through doing my angel card readings and bringing forth individualized Divine guidance.

Acknowledging the Divine energy all around me has given me a sense of comfort in my life. Honestly, I still struggle with some fear and anxiety, but it is much less present in my everyday existence. We all have struggles of some sort during our lives, and these difficult times help our souls grow and fulfill each of our paths.

Follow your joy. Seek out your soul's purpose by connecting with the Divine energy that is all around you, and you will feel fulfillment and a sense of wholeness even when faced with life's challenges. Follow the path that feels right for you, no matter what others tell you. The last line from my mother's favorite poem by Robert Frost, *The Road Not Taken*, perfectly sums up this notion: 'Two roads diverged in a wood, and I—I took the one less traveled by, and that has made all the difference.'

Christy Yacono

Christy Yacono, ND, CNHP, NDE, chef, and author is a born and bred Chicago native. Holistic health has always been her calling. Diagnosed with ulcerative colitis at the world-renowned IBD Research Hospital, the University of Chicago Medicine, her own health challenges at a young age empowered her to start a career with a passion for integrative medicine.

Christy received a Doctor of Naturopathy from Trinity School of Natural Health, is a Reiki Master, studying Enzyme Nutrition at the Loomis Institute, and is currently pursuing her doctorate in Naturopathic Medicine at the National University of Health Sciences as first-contact, primary-care doctor.

Christy, a holistic health advocate, is helping others to understand Whole Body Healing utilizing traditional and modern therapies that encompass the body, mind, and spirit. Modalities include Reiki, Healing Touch Therapy, nutrition, botanical medicine, Flower Essences, homeopathy, enzyme therapy, and much more.

November 18, 2010 marked yet another amazing chapter when Christy walked on stage to accept an Emmy for Outstanding Musical Arrangement for her gifted late husband, Patrick Yacono (director, sound designer & composer), who passed in October 2007. It fulfilled Patrick's lifelong dream of winning an Emmy. It proudly sits on the living room fireplace mantel, where it serves as her inspiration.

Thank you, Mom, Dad, and Bill for supporting me along my journey. It's been an honor and I would do it all over again with you. All my love, Christy.

Contact Information:
For more information: www.mondoesqe.com

Thirteen Squadron Angel

By Christy Yacono

But now was turning my desire and will,
Even as a wheel that equally is moved,
The Love which moves the sun and the other stars.
~ Dante Alighieri, *Paradiso, Canto XXXIII*

I'm lying on a bed in the emergency room in Quebec. Frantically, Canadian doctors and nurses are moving around, hooking me up to an IV drip. My parents, distraught and worried, are trying to answer all the doctors' questions regarding my condition.

I vaguely remember leaving the hotel room, not feeling good after a day at an amusement park. My dad loved roller coasters, so family vacations for longest, tallest, and fastest coasters were our yearly getaways.

Drifting in and out of consciousness, I hear the doctors talking a diagnosis—high fever, major blood loss in the abdominal area, possible acute leukemia. A transfusion *STAT!*

There wasn't any time for sedation; a doctor quickly hovered over me, holding a long, thin needle and inserted it deep into my chest. It felt like they were breaking my chest plate, trying to extract fluid.

"I'm sorry, Mom and Dad, for ruining the family vacation." I didn't have the words to let them know I had been wanting, waiting to leave. Being sick for over a year, I kept my illness a secret; I didn't want my family to be upset. Something had been

happening inside me for a long time—internal bleeding, excruciating pain in my stomach. It hurt so bad.

Now, my physical body, no longer functioning, was shutting down, but my destiny within awakens.

I was surrounded by the crisp, static blackness of space. The ethereal darkness didn't seem to have a connection to me as either good or bad. Immersed now in pure, infinite space, a harmony all vibrant, welcoming, and soothing. Everything heightened in sensation and aware of the Creative Forces.

I became aware of my parallel existence. Communicating, but not by talking, like I once knew. It was as though my thoughts used in the mind as inner talk now became a real energetic form of true communication.

The Divine Voice responding to me is beyond my vocabulary, everywhere, commingling all present at the same. Omnipresent. God, Highest of Creative Forces. There is no physical shape to describe this Magnificent Presence. Beyond form, since human form is not needed, where universal physical laws no longer exist in the "Inter-between," the "Borderland."

Previously with a third-dimensional mind, I am now moving as a being of light, every fiber instantaneously emitting an exchange of all knowing. I'm aware. My "personality" has shifted. No longer am I a mortal child physically aged fourteen, but now am of a soul state, a being of emanation, the real self, discussing a "my recent past" on earth.

The Divine Illuminating Voice emanates my lifetimes with me by indescribable energy projection (forces) of family and friends. All power, glistening with the most exquisite love for all of my life. A result only from life's love expressed. Everywhere are thousands of people with whom I am connected at a moment, all part of the Earth experience. All the physical experiences I accumulated in sequential moment-by-moment events have an exact purpose transposed with mutual souls intricately woven.

> *Know that the birthright of every soul*
> *is a choice or free will.*
> *~ Edgar Cayce*

Revelation of Light

Destiny is complete (I'm told), joyous, fulfilling my purpose of material sojourn accomplishing the cycle in the magnified sphere. Completed to my soul expectations, my body had accomplished the way, utilizing emotions or atomic energy patterns. I fully comprehend all that is, imbued with love. It is where I am meant to be now, and the cycle continues for me to further my soul's work—my true calling with my squadron, awakened from a deep earthly sleep.

Each soul has this birthright, the ability to choose its experience. Free will. Upon my life's review, my soul would fully grasp material wealth, material poor, catastrophic illness, grief, and loss, in this present life. BUT, in all trueness, I am not ready to leave, my family, my personality known as Christy, a fraction of many personalities acquired over eons of journeys.

The energetic pathway would open for miracles, a gift, if I chose to remain earthbound. I was to prepare for a transition time, since my body had bled to death, causing permanent damage to my colon. I saw how this affected me; I saw what I would endure. I experienced projections of each medical procedure performed with my Angelic Squadron alongside me at all times. This would be an important lesson, for the ability to see what lay ahead would be a gift now. But, I would never speak of it as a gift. A cycle called "Hell" would be around seven years in physical time, where divine healing would take place.

I saw outcomes (expressions) of my departure and now my new future. *The choice to return was not, and should not be made based on karmic repercussions of my soul group, I was gently reminded.* Preparations had begun (around six months' prior earth time for everyone) for my arrival, and I was wanted,

expected, at HOME. But, my squadron was way ahead. And, my healing had begun on another level.

Soul Survivor
My choosing to return to my body was not without complications. My intentional shift within Heaven's Sphere to stay in the physical would create a new group of energies for my new personality. Somewhere deep inside, I carried the shame of knowing it was not truly my Divine Destiny to stay in the material place. In understanding the Universal Laws of souls, staying for the soul family was not for my attained development.

Nevertheless, I had to return to my physical body. I can foresee projections surrounding my death and its outcome. Many miracles bridged with this new energy would be brought through to Earth. This cause and effect now would change course for my new life, future and outcomes, all in a moment's time. Always knowing I was never alone on this journey back.

Divine healing energy would be pushed through a vortex attached to me. This spiritual/human connection is called "The Silver Cord" and each one of us has it. My belief is this is actually what people see as they leave their bodies, and go through the tunnel. This silver tube, a stunning, ethereal, shimmering vortex, which is actually moving or spinning, is located around four inches from the abdomen area and goes directly up, although some have seen it come up through the crown area.

From that point on, I would live—as an NDE (Near Death Experiencer).

Spiritual Quest
The way I re-entered my life changed dramatically. A new level of diagnosis loomed on the horizon, the beginning of a new era of medicine in the 1980s, and it had to do with pharmaceuticals. Transferring to a pediatric section at the University of Chicago, one of the world's preeminent research institutions featuring

some of the nation's leading experts with inflammatory bowel disease, my blessings began.

Being a critical case brought into the hospital grabbed the attention of many doctors in Gastroenterology. A brilliant, vibrant woman Professor of Pediatrics and Medicine Director, IBD, was eager to work with me. As part of the IBD program, I would be there for the next four years, until the age of eighteen.

For the first year, my illness was waiting for a name. We learned in this time, a new drug was about to emerge for inflammation, a type of steroid. I had to wait until this new drug came out to be given the name of my disease.

It was really interesting to take notice, since I was now emerging into a system of medicine grouped by physical complications, AND, then I could be treated as such. Officially, I was diagnosed with an Inflammatory Bowel Disease called Ulcerative Colitis, no known cause, no known cure. From what I remember, this new diagnosis would also open up a plethora of experimental drugs to be used on me at any given time. My mom had to sleep with me at the hospital initially, for doctors would come in, asking for my signature for treatment if no parent was around. I was also grateful to have my doctor close by with her watchful eye at all times.

I always was aware of what was happening to me. I could hear the doctors discussing me, some nice, some not so nice. I could move back and forth from my body, to outside my body when the pain got too intense. When I left, I could hear all the thoughts everyone was thinking; it was strange for me to see that most of their thoughts did not match the words coming from their mouths. I didn't think badly of anyone; I just didn't understand.

I spent most of my teen years at the University of Chicago, with stays sometimes lasting for months, depending on how much internal bleeding and how much ulceration developed in my colon. Numerous transfusions, experimental iron therapies,

and steroid medications were standard procedure. I consistently tried to explain (to whoever was around me at the time) that certain foods bothered me, or that milk gave me headaches, as well as stomach aches. In the eyes of the specialists, however, food was not an issue that correlated with inflammatory diseases. I was way ahead of my time.

One day, a supplementation from a book found at a neighbor's garage sale by Adelle Davis called *Let's Eat Right To Keep Fit* caught my attention. Davis believed in widespread deficiencies from lack of essential fatty acids (fat is necessary to stimulate the production of bile and the fat-digesting enzyme, lipase). She knew there was little value in improving health if digestion was not working properly. She also discussed Vitamin A and B deficiencies, and much more! In addition, she addressed the psychology connection involved with eating, conscious and subconscious.

This was the beginning of preventive medicine; I had to know more! I had found something I physically could refer to, instead of "attuning" and began to apply my spiritual and physical connection together as one. To this day, I still have all three of her books, including *Let's Cook It Right* and *Let's Get Well*.

> *You grow to Heaven; you don't go to Heaven.*
> *~Edgar Cayce*

When I turned twenty, I was told my colon was no longer functioning properly; the disease had pummeled through it. Many polyps had formed. Although I was in better health than I had ever been (secretly taking myself off steroids meds), cancer was a big possibility. I decided to undergo an experimental surgery, a total proctocolectomy (removal of the colon, rectum, and anus). A stoma for the diversion of intestinal contents for a year or two while the area healed would be necessary. Finally, I

would undergo a restorative proctocolectomy with an ileoanal "J-pouch" anastomosis. In this procedure, following the removal of the colon and rectum, a portion of the small intestine is formed into a pouch and connected to the anus. Surgery would take 12 to 13 hours for the removal.

There was only a 50:50 chance this unknown procedure would work, and that I would survive this invasive procedure. Information regarding my healing was constantly being "downloaded," setting things in motion for the future, healing the past while being present—a gift I was given and utilized at all times. I already knew my outcome was a success.

My sister once made a comment when looking back at this time, from the family's perspective, "I was never told you would survive the surgery. Mom and Dad never talked about it. It was just something I always knew. Like it was meant to be."

The connection my sister made was profound. Although I wouldn't hear this until much later in life, my family had known the truth, the power in knowing would help all of them go on to attain beautiful lives of their own.

Death is not what it seems; Life is the illusion.
~ The Great White Brotherhood

Thirteen's numerological influence is a gift and a curse. Thirteen's cause and effect in the material world. My birthday would bring a plethora of constant change ever within my reach. The weight and balance of the Universal Laws must be continually reviewed; morally, like a swinging pendulum.

I continued to make my way through stress, fear, grief, and loss twice—in a vision or premonition, followed by the experience … a gift or a curse? Having shared with you only a miniscule amount of information, Truth was a growing thing, even for me.

I turned fifty this year. To date, I am one of the oldest living J-pouch "heroines." I do not have a large intestine or gallbladder.

I have a rebuilt rectum, and half of a small intestine; other half was made into a J-pouch. Sixty-plus staples hold my small intestine in place. There is also lower spinal damage from the length of surgery.

However, you wouldn't know that unless I told you—since my Squadron is THAT GOOD. More importantly, my entire life has been about seeking the magic of our Spirit, co-creating with our teams of angelic beings and our soul lessons on this beautifully intricate planet. I was hit hard with experiences that remain beyond the range of normal definition, as if my life flows with spiritual continuity.

What was to be the most challenging is to know that I travel this path mostly alone. It's not the same as being lonely, which I completely assure you, I am not, and neither are you. I've chosen to honor the Spiritual Truths—the Laws I've come to understand exist in Mondo (The Universe).

Seeing Archangels, working with the Ascended Masters, also known as the Great White Brotherhood (who have the most beautiful, long, white beards) and my Squadron is all I know. Magnificent in energy, wings are only for physical description.

Superstrings

The Earth has an amazing balance of incredibly magnificent energies. With proper use and understanding, it can catapult a human into soul growth, expound on the mysteries that are hidden to the untrained eye of the average, but leap out at those who seek it and trust. It's truly about partnership—a partnership with Earth, souls, soul growth, and energies. It can be seen with just the limited knowledge known! Black and white, good and evil, life and afterlife—are ALL PARTNERSHIPS. Each one of them is equal and important. Placed strategically in partnership —(which is a soul longing)—coming here to experience. To live love is to be love.

The Wonder of ALL

Each new encounter brings with it a Squadron member specific to healing, understanding, and our spiritual growth. The flow is astounding. The matrix methodically flows all around you. If you are like me, you'll be down-on-your-knees grateful for everything the Squadron knowingly and unknowingly does.

Learning about cause/effect opens an energy wave in your soul group, which can then provide a gateway of new options, a brand-new way to respond in a given situation based upon choice, especially in dreamtime.

Pulling through new information like the great minds of Edgar Cayce, unfiltered, can create unity and compassion in a living world. This matrix is very much continuous. Composed of space, time, matter, spiritual matrix, biological, and sentient beings, this intricate system is beyond anything you can comprehend. Open your heart and let your journey begin. Your very own team of Angels is watching over you, patiently awaiting your heart's most true desire.

This chapter has been infused lovingly for you with Divine blessings. ♥

References

Dr. P.M.H. Atwater's book, *The Big Book of Near-Death Experiences* references four types of near-death experiences., based on her years of research. Dr. Atwater, L.H.D. survived three death events that produced three different near-death experiences in 1977. She is one of the original researchers of near-death phenomena, having begun her work in 1978. Children's near-death experiences were covered in-depth in Dr. Atwater's book *The New Children and Near-Death Experiences.*

I have had the recent pleasure of learning my NDE has been categorized as "Initial" (sometimes referred to as the "nonexperience") with 76 percent of child experiencers. For more information, please visit http:// pmhatwater.hypermart.net

Afterword

*I*t has been an amazing blessing to work with so many women and catalyze their dormant intuitive gifts and abilities, their innate healing powers, and the wisdom within, as well as those who already work as professional healers and intuitives. What an honor to have these women contribute their insights and stories in the Inner Circle Chronicles series.

At this critical time in history, it is very important to facilitate more transformational shifting and raising the awareness on the planet. It is a dream come true to have my message and those of the contributors to this book be out there, to inspire and help others do the same.

I look forward to sharing the next book in the series, in which a brave man has also stepped up and out to share his message about Divine Power, healing, higher consciousness, and intuition.

For those of you reading these words, thank you and may you be blessed with recognizing your own innate well-being, total wellness, and Divine health.

Many blessings,

Anne Deidre

About Inner Visions Publishing

Intuitive Life Coach, best-selling author, and spiritual thought leader Anne Deidre created Inner Vision Publishing in 2013 to offer an avenue for spiritually based authors to share their wisdom with the world. Anne is the editor of collaborative works, in which co-authors contribute a chapter on a particular theme. She also supports individual authors seeking personalized attention, coaching, and intuitive guidance in developing, writing, and publishing their books. In some cases, Anne also helps her clients create and build businesses around their books through workshops, coaching, public speaking, and other modalities.

For more information, please contact:

www.annedeidre.com

Anne Deidre
Inner Visions Publishing
Giving Voice to Spiritual, Intuitive Artists and Writers